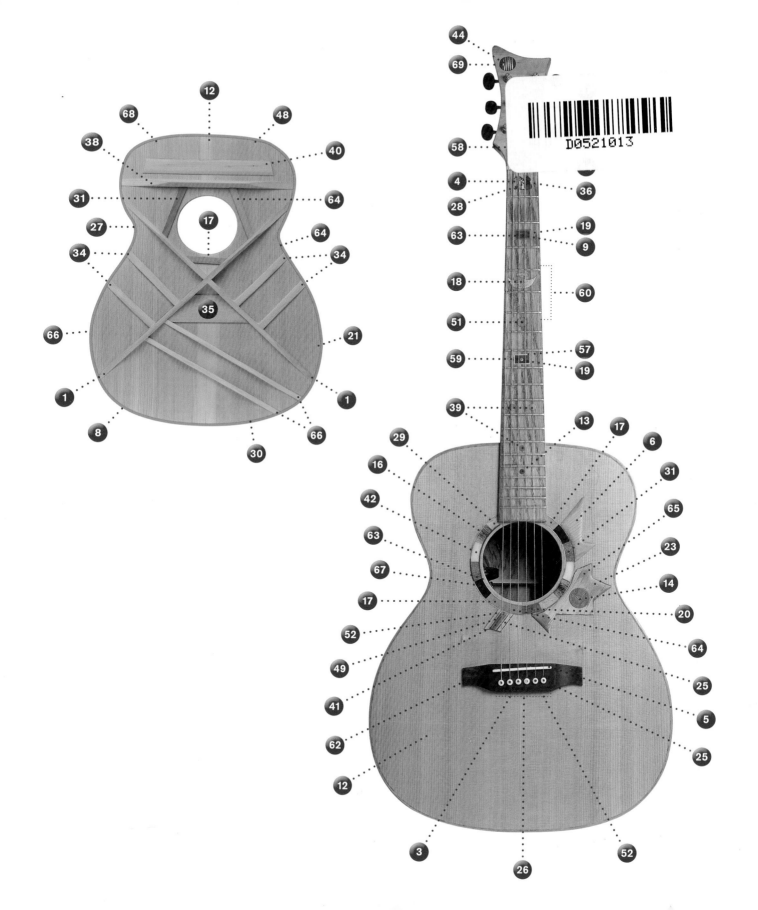

D0521013

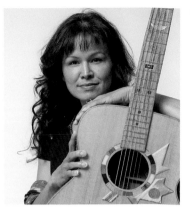
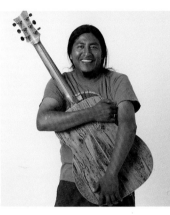
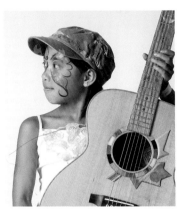
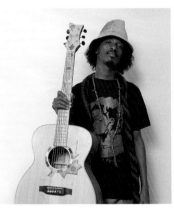
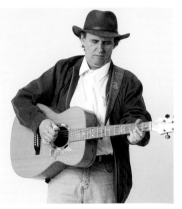
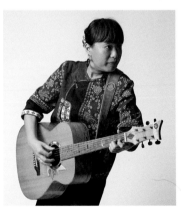
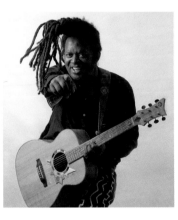
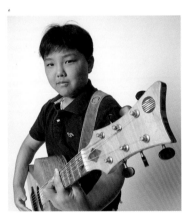
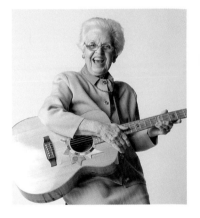
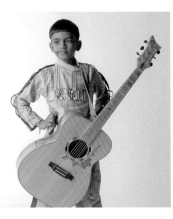
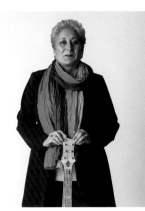
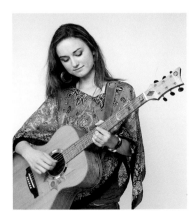
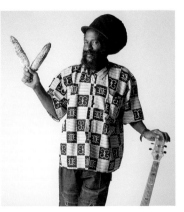

Jowi Taylor

SIX STRING NATION

64 PIECES · 6 STRINGS · 1 CANADA · 1 GUITAR

photos by Doug Nicholson and Sandor Fizli

DOUGLAS & MCINTYRE

D&M Publishers Inc.

Vancouver/Toronto/Berkeley

Douglas & McIntyre
A division of D&M Publishers Inc.
2323 Quebec Street, Suite 201
Vancouver BC Canada V5T 4S7
www.dmpibooks.com

Library and Archives Canada Cataloguing in Publication
Taylor, Jowi
Six string nation / Jowi Taylor.
Includes bibliographical references.

ISBN 978-1-55365-393-6

1. Guitar—Construction. 2. Taylor, Jowi. 3. Nationalism—Canada. I. Title.
ML1015.G9T243 2009 787.87 C2009-900321-X

Editing by Peter Norman
Cover and text design by Naomi MacDougall
Cover photographs by Doug Nicholson (portraits) and Sandor Fizli (materials)
Printed and bound in Canada by Friesens
Printed on acid-free paper
Distributed in the U.S. by Publishers Group West

We gratefully acknowledge the financial support of the Canada Council for the Arts,
the British Columbia Arts Council, the Province of British Columbia through the
Book Publishing Tax Credit and the Government of Canada through the Book Publishing
Industry Development Program (BPIDP) for our publishing activities.

On the long road of building the Six String Nation, I have often been overwhelmed by weeds of doubt: that the project was impossible to accomplish, of questionable value, subject to derision or, worse, indifference. These seeds were planted by others but did take root in me from time to time.

Over and over again, those weeds have been cut back by a blooming profusion of feeling for Canada that I've encountered in Canadians of all ages and all backgrounds, in cities and towns, in large corporations and small communities all over the country. In part, this book is dedicated to those constant gardeners of a wonderfully wild and tangled vision of Canada where all kinds of possibilities grow.

One Canadian in particular put in countless hours of help: doing any kind of task, learning any kind of software, going anywhere I asked her to join me. She has been a bottomless source of optimism. Her name is Sarah and this book is dedicated to her, too.

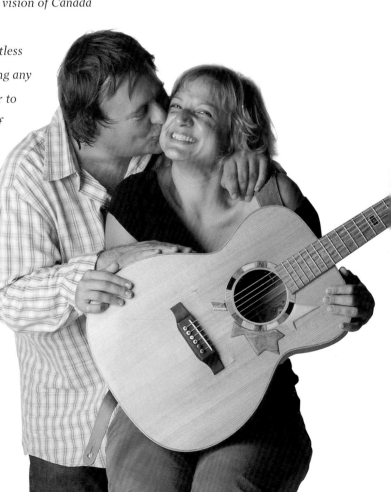

«GÉNÉRATIONS»

SIX STRING NATION, SUDBURY, TOWNEHOUSE, le 31 août 2006

1)
et cela sonne et resonne et résonne sur des 10aines de milliers de milles
et des milliards d'années ce bois-ci cette corne-là cette roche d'ici
et d'ailleurs

quels sont les sons de ces pays naturels et humains rythmés par
des accords de tristesse mineure comme d'espoir profond comme
un trou de mine de quels lointains horizons venons-nous vers une musique
qui ne nous scinde pas qui nous transcende dans le droit fil
sur le plancher de danse de nos cœurs chercheurs de danseurs bleus

quelles sont ces chansons que j'ai chantées main dans la main avec
une très belle fille et celles qu'elle m'a fait découvrir
elle sourire en coin moi larme à l'œil celles qui sans nous unir
nous réunissent sudbury saskatoon shuswap chicoutimi
tous les saints et les saintes cap d'espoir cape despair cape spear
couplet refrain bridge coda
et
cela sonne resonne résonne

2)
this playing is work this work is playing with time space laughter friendship
all shared & shored up with crazy love and strange times from 5/4 to
immemorial this song is a creation a talisman a child dancing her way into
and among this world where others run amok

this is innocence good as good music & good courage & good people are good
breaking bread in a common accord touching and being touched
moving and moved into the music
the mystic the real real gone

work & play that thing forever on & on & on & on

& i will dance in suspended animated amazement tout est possible
même notre humanité malgré tant & tant

as my shoulders my knees all my public parts joice & rejoice
on this hard hard ground where music rhymes with
people get ready

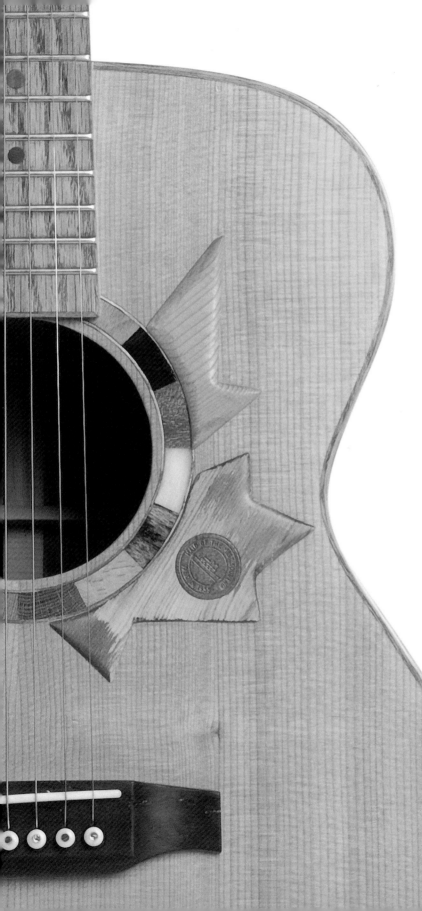

3)

who

are you really truly

what

tell me what is goin on

why

do i cry when they play that thing

when

will i ever get over it

where

can i find something good on the radio

qui

joue de la guitare de même

est-ce le fils ou le père

quoi

faire sauf danser sinon je m'effondre

pourquoi

c'est de même toujours saisi jamais compris

quand

est-ce que ça va arrêter jamais je l'espère

où

pourrais-je être mieux dans

le pays entier le monde entier

mon cœur gros

et entier

que dans la musique qui

vient de partout

temps espace tête cœur

tout sonne et resonne et résonne

on & on & on & on

tous les jours pour toujours

ROBERT DICKSON

© l'auteur 2006

PREFACE

SOMEWHERE IN MY PARENTS' BASEMENT is a picture of me in a giant sombrero with my name sewn on the brim, taken at Expo 67 in Montreal. Like so many of my generation, my sense of what it meant to be Canadian was fused in the promising glow of that centennial year, when we officially opened our arms to the world and our minds to the idea of a cosmopolitan Canada. It was an invitation to choose who we wanted to be as a nation, how we wanted to define ourselves to ourselves—and to the rest of the world. But what definition to choose? I feel the same confusion when I confront a wall of CDs and can't decide what I want to listen to, or when I stand before the baffling menu at the Booster Juice bar: so many options, so many desirable ingredients, so many combinations to consider that I end up paralyzed by choice. The people in the vast line-up at the Tim Hortons next door to the juice bar don't appear to be so conflicted. This seems to me to be the essential problem of Canadian identity: a rainbow of options—grand and virtuous—that devolves into the simple but comforting cliché of a bunch of people standing around eating donuts and drinking coffee and feeling "better than the Americans"—even if that's who they're ultimately buying their donuts from.

I have nothing against coffee and donuts. Or hockey. Or beavers or loons or the CN Tower or Lake Louise or five-pin bowling or insulin or any of those other things we embrace as being quintessentially Canadian. It's just that, for me, they never seemed to reflect the generous range of cultures, experiences, stories and viewpoints that we were supposed to be so proud of.

In 1995, I set out to find something that would reflect us better, more fairly, more interestingly, more uniquely—something that would be at home wherever it was in Canada, something that could be Aboriginal and English and French and Immigrant all at the same time, that could put prime ministers and rebels and sculptors and hockey players and inventors and oyster shuckers all on one stage singing different tunes and have it sound like one voice.

With the help of one brilliant craftsman and hundreds of Canadians with stories to share, that something turned out to be a really simple object—an acoustic guitar—that's become the most complicated, confounding, inspiring and rewarding thing I've ever done, a project that changed me and changed the way I think about this country.

This is the story of Voyageur, the Six String Nation guitar.

1

HALIFAX, NS
Rafter from Pier 21. From 1928 to 1971, this port terminal building was the primary point of entry for over one million immigrants to Canada. It also welcomed one hundred thousand refugees, fifty thousand war brides and their twenty-two thousand children, and three thousand evacuated British children escaping World War II. It was also the departure point for thousands of Canadian soldiers and air crew heading off to war. In 1956, it was the entry point for luthier George Rizsanyi and his family from Hungary. It is now a museum.
COURTESY OF: Pier 21, with help from Carrie-Anne Smith and Vice Admiral Duncan Miller

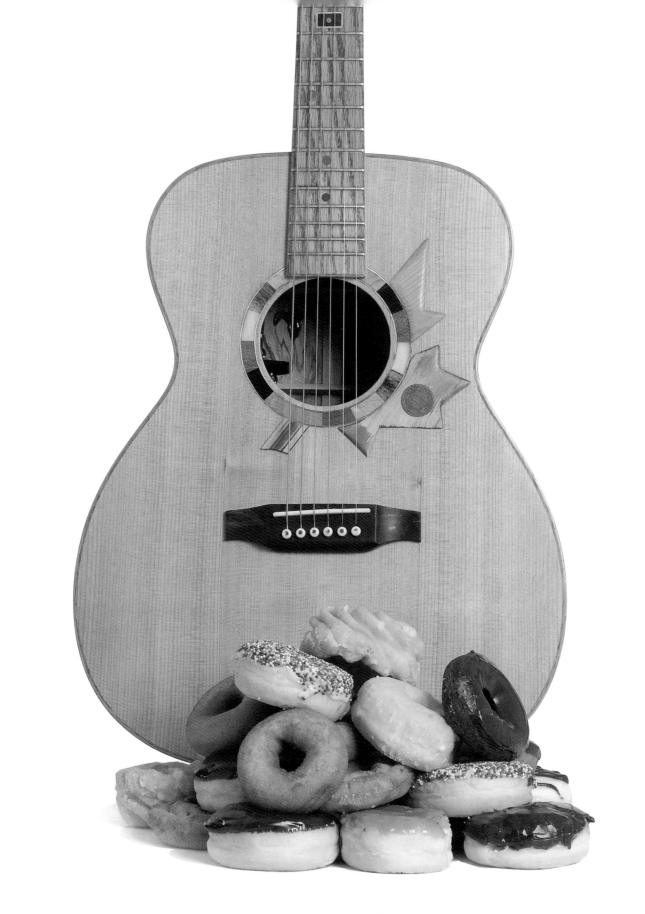

E A D G B E

BEGINNING

MUSIC HAS BEEN THE CENTRE of my life since I first figured out how to drop a needle on a record. Before I started amassing a record collection at the age of nine, I had explored every groove in my parents' record cabinet. I think my parents were a little bit dismayed at the sheer volume of attention I paid to music—not to mention the sheer volume at which I liked to listen to it.

As music was to me, so politics was to them. While my parents hosted riding association meetings, I was in my teen-den in the basement with the headphones turned up loud. For me, music contained the spark of all kinds of power—physical, spiritual, emotional, social, cultural *and* political. The political power, for me, grew not just from lyrics (as it did in so much of my parents' collection) but in a song's very structure. The music of a Ghanaian drum ensemble or mid-period Talking Heads was more politically suggestive, I felt, than most protest songs. Once you got lyrics

involved, you got someone's point of view—possibly misinformed, possibly earnest, possibly missing the point entirely.

That's how I felt in 1995, as the province of Quebec steered hard in the direction of sovereignty with the October referendum. As the decision loomed, the drama played out in the cool calculus of politics and the heated passions of culture, with warm (sometimes itchy) sentiment softening up the middle ground. I sympathized with Quebec nationalism as an expression of cultural confidence. Then again, I also understood those people who chartered buses simply so they could stand on the streets of Montreal to declare their undying—and normally unarticulated—love for Quebec as an essential part of Canada.

But as I listened to debates and then on referendum night watched those blue and red graph-bars battle for real estate on my TV screen, I felt we were missing something really important. This wasn't just about Quebec versus the rest of Canada, it wasn't about French versus English, or politicians and intellectuals grappling for control of our constitutional history. Canada is filled with stories from communities large and small, stories that flesh out the character of who we are. Sad tales, grand tales, tiny acts of revolution or invention that resonate with some small part of us, whether we're from First Nations or founding nations or the United

2

MONTEBELLO, QC
Moulding from the interior of the Manoir Papineau, the house built on the seigneury of French-Canadian politician and early Quebec nationalist Louis-Joseph Papineau in 1850. COURTESY OF: Joanne Beland, Manoir Papineau, Parks Canada

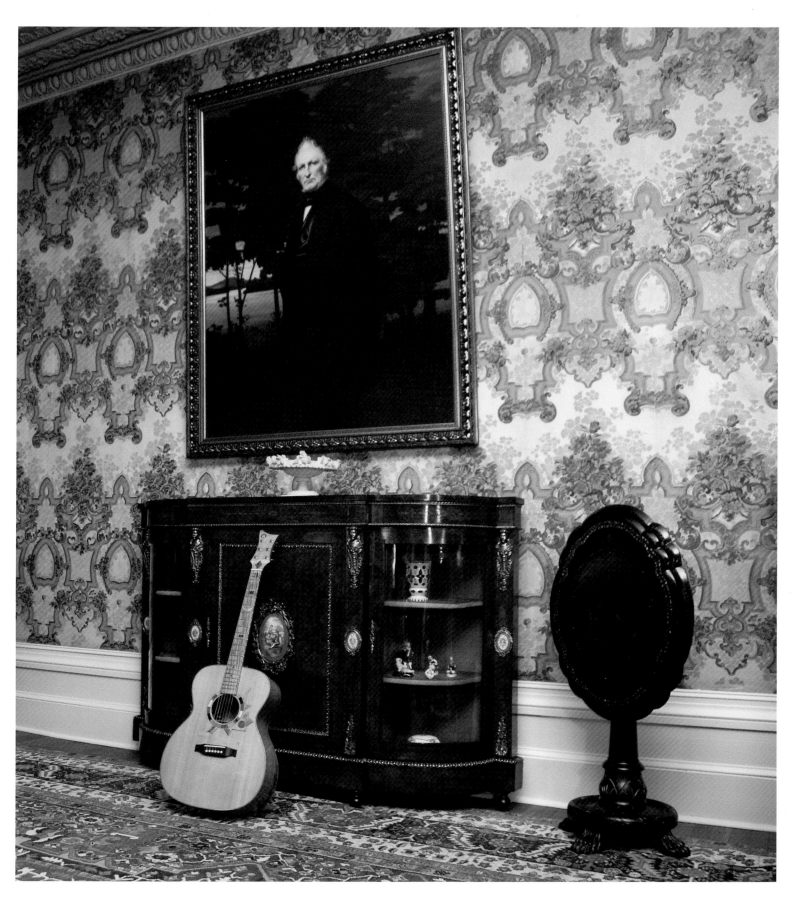

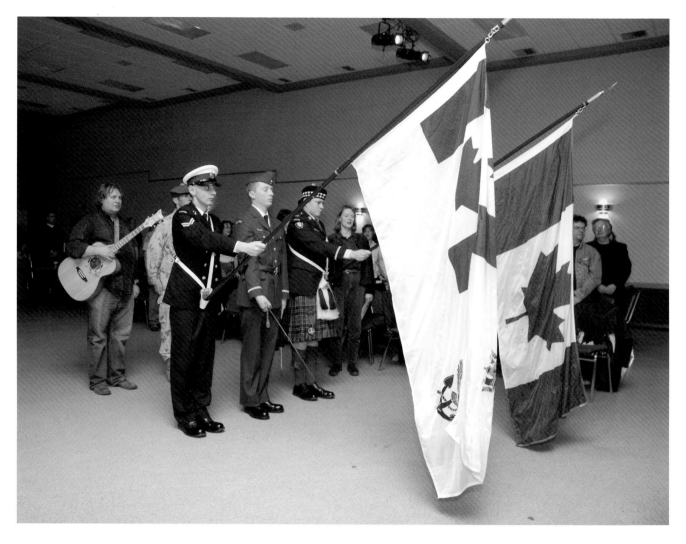

Entering Prosvita Hall in Thunder Bay, ON, with the military Colour Guard

3 **RANKIN INLET, NVT**
Walrus tusk. COURTESY OF: Brian Hart

Nations we have become. During the referendum, none of those stories passed the lips of pundits or politicians of any stripe.

A few months before the referendum, I happened to meet a guitar-maker named George Rizsanyi. A Hungarian immigrant and former auto worker, George had made a name for himself building guitars from Canadian woods rather than the exotics favoured by most in the trade. As he saw it, people paid huge sums, destroyed rainforests and skewed local economies just to get at materials for which there were equivalent or superior homegrown substitutes. George even made guitars using wood from his property in Greenbank, Ontario. This quietly patriotic act seemed counter to how Canadians tend to think—that if something is from here, it must be second-rate. Perhaps the reason for this referendum was that Quebecers were prepared *not* to think that way about themselves. And perhaps Canadians in every part of the country longed to express themselves as boldly as Quebecers did. If our local stories weren't constrained by self-doubt, perhaps we could all experience that boldness together.

I asked George if he could build a guitar using material from every part of the country—one piece from each province and territory. George agreed to give it a try. We thought we might have it done in time for the referendum. We couldn't have been more wrong.

Excerpt from a letter written by philosopher, author and University of Toronto professor Mark Kingwell to Heritage Canada in a bid to procure funding for the Six String Nation project:

THE GENIUS OF Taylor's project is its syncretic quality, the gathering of diverse materials—wood, metal, steel, bone, and stone—into a unified instrument that will, in its diversity, express the peculiar post-essentialist character of Canada. These materials range across cultures and eras, locations and resonances. They include the sublime and the ordinary. Always there is a sense that the gathering, and coalescence, will literally strike a chord, finding harmony in difference.

I understand that there is some concern within Heritage that the removal of these diverse objects from their current or original context will, in effect, nullify them as artifacts. I am not an anthropologist and so speak without expertise on this issue, but as a philosopher and a Canadian let me express the opinion that this removal from the originary—itself a mythic category— is far more expressive of Canadianness than any search for ultimate cultural authenticity. The appeal of Canadian identity has always been its fluidity and contingency, its sense of spectral union. The Six String Nation guitar will be a kind of floating signifier of all the complicated things we mean when we talk about Canada.

MARK KRISTMANSON

There was a time not so many decades ago when the great American baritone Paul Robeson travelled the world ferrying the folk music of different nations and cultures between peoples and places. In their warm response at every concert, audiences affirmed a commonality in the song form that Robeson believed bridges all cultures and societies across time. The Six String Nation guitar is the Canadian talisman of that insight. Indeed, the resonance vibrating in the fine grain of its sixty-four constituent artifacts will influence our popular music tradition. Looking closely at the expressions of some of the thousands who, like Kyrie and me, have been photographed playing it, one witnesses people in all their moods and modes assuming their place in a wider artistic and historical public consciousness. There is a dignity that manifests itself when art, history and people are conjoined in such positive acts of remembrance and creation.

For this reason, it is inspiring that the guitar has found its supporters and helpers even beyond the community of musicians: among high school students, for whom it is a powerful heuristic for understanding Canadian history; among music lovers of all ages, for whom it is a connection to illustrious musicians who also have played it; for those who identify with a regional or local historical connection it embodies; among First Nations, Metis and Inuit communities who contributed meaningful cultural artifacts to its creation. Finally, here and there in corridors of business and government, there are those who understand the interdisciplinary significance of the Six String Nation project: a composite artifact of historically significant material culture that occasions the transmission of sounds, songs, musical experience and public memory on its limitless Canadian voyage.

ONE ARROW FIRST NATION, SK
Stone from the monument to Almighty Voice (a.k.a. "Kisse-Manitou-Wayo" or "Shu-Kwe-weetam"), killed in the last battle between natives and the North West Mounted Police on June 1, 1897.
COURTESY OF: Brian Chipperfield and the One Arrow Band

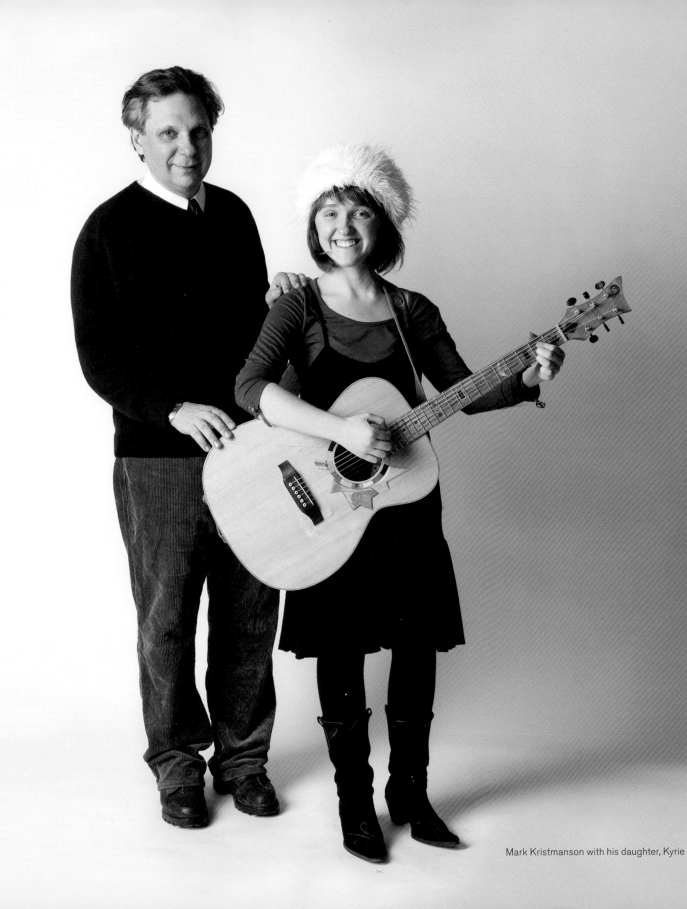

Mark Kristmanson with his daughter, Kyrie

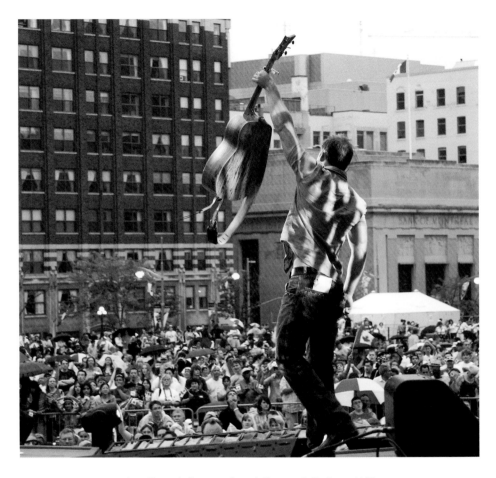

Jean-François Breau on Canada Day 2006, Parliament Hill

5

PLACER GOLD CLAIM, YK

Mastodon ivory. Originally found on a Yukon gold mining claim, this piece passed through many hands before winding up in the guitar. COURTESY OF: Russell & Katherine Gordon

I'm often asked how long it took to make the guitar. I have two answers. Aside from preparation time, George spent just six weeks between April and June of 2006 building Voyageur, with Sara Nasr parachuted into the workshop for one week to work on the fretboard inlays. But the other answer is that, with all the research, consultation, futile attempts to get funding, the meetings and letters and phone calls and e-mails and endorsements and false hopes, it took eleven years from that magic moment of conception until we heard the first sound from this guitar.

While I spun my wheels, other projects emerged that seemed to tap into the same zeitgeist—a collective notion of nation. Author Charlotte Gray's *The Museum Called Canada* looked at the country through twenty-five virtual rooms filled with the objects of our memory, meaning and culture. Tyler Aspin, an artist from Pinette, PEI, built a sculpture called *The Canada Tree* made from items contributed by people from across the country. In tribute to Tyler, the rosette of the guitar includes pieces of the mallet used to build the tree. Tyler died of a lightning strike in 2001, before we had a chance to meet and become friends.

My guitar remained a frustrated dream even after an article on the front page of the November 26, 2005, *Globe and Mail* attracted all kinds of kudos but no funding. But when Mark Kristmanson, director of events for the National Capital Commission in Ottawa, called to ask if the guitar would be ready in time to be featured in programming for Canada Day 2006, I took what funding promises I had, multiplied them in my head and simply said yes. Even though the main funding promise would ultimately fall through, I knew this was the best opportunity to debut the guitar the way I'd dreamed. Even if I was flat broke, how could I say no?

ALBERTA

We had almost all of the pieces ready to go in George's workshop in Pinehurst and we'd set a deadline of April 30, 2006, for receiving anything new. A few pieces had yet to drift in, but basically George was ready to begin work in earnest. A proposed deal with CBC Television to document the project had fallen through, but thanks to a sponsor I was able to hire a high-def video crew to capture critical points in the building process over the course of a few visits. On the first of these occasions I went to Pinehurst and met the cinematographer, Doug Munro, and his partner, sound recordist Margot McMaster. According to the director, Blaine Philippi, they were the best in the business, so it was worth it to bring them in from Alberta for the job. Ultimately, they became so enamoured of the project that they paid their own way from Alberta for the final session.

During a break one day, Margot told me that she and Doug lived on a ranch south of Calgary, in the shadow of John Ware Ridge. She asked if I knew the story of John Ware. I didn't. She told me his tale, and I became instantly obsessed with including it in the guitar. Growing up in Ontario, I was taught early about the Underground Railroad, and in high school we learned about Nova Scotia's "Africville" but we never learned about John Ware, the slave-born Carolinian who became a legendary cattleman and local hero in southern Alberta. This represented what the project was really about: revealing Canada to Canadians, challenging our regional assumptions and letting the big and small stories of our history mingle together in this one instrument. A few calls and e-mails to Dinosaur Provincial Park, where John Ware's original cabin now resides, and we soon had a piece of the cabin for the guitar. George included it as the top element of the pick-guard (though credit must go to video co-director and lighting designer Bob Stamp for the idea to rotate the whole assembly slightly, giving it a much more dynamic appearance).

6

DRUMHELLER, AB
A piece from the cabin of John Ware, Alberta's first black cowboy and a respected entrepreneur, pioneer and rancher. Born into slavery in South Carolina *circa* 1845, he died a legend on September 12, 1905, 12 days after Alberta became a province of Canada. COURTESY OF: Dinosaur Provincial Park, with help from Fred Hammer

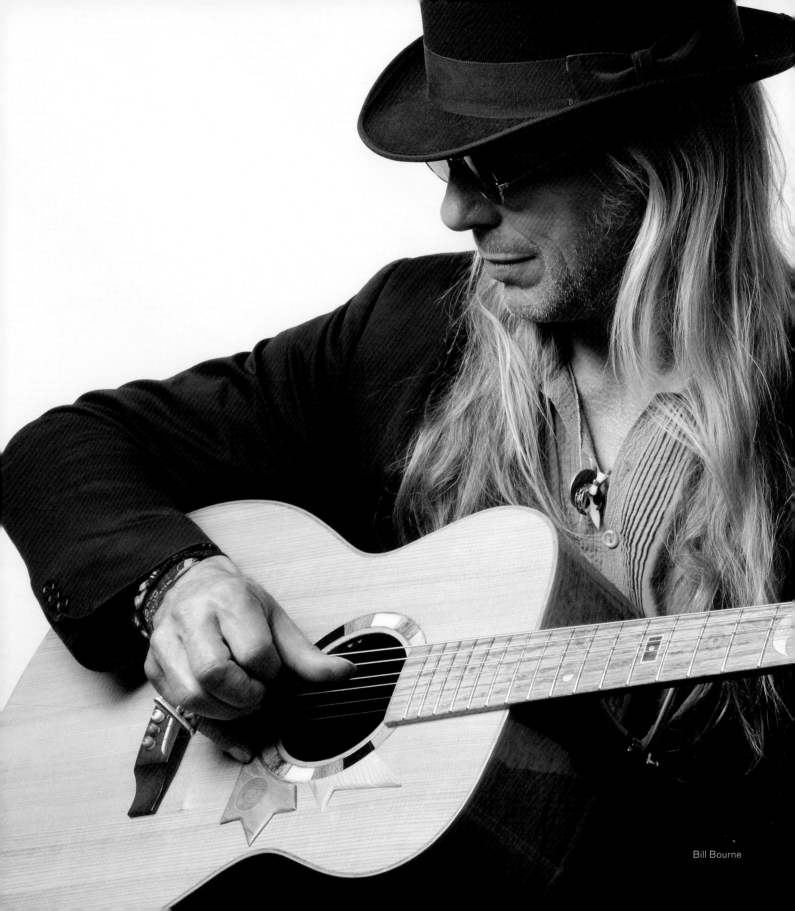

Bill Bourne

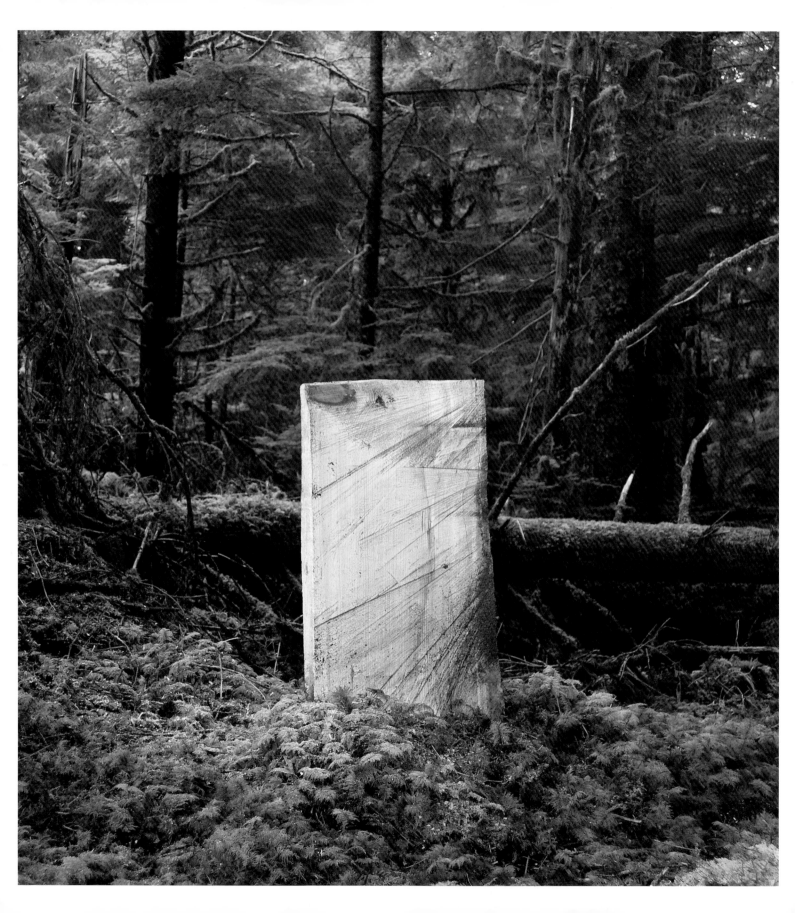

E **A** D G B E

HAIDA GOLD

I T TOOK ALL KINDS OF support—moral, financial and creative—to bring this project to life. I received help from countless people, many of whom you'll find listed in the acknowledgements section of this book. They contributed introductions, sponsorships, personal cheques, phone calls and more. One person in particular had a small but catalytic role. He didn't give any money. We spoke only once. But his contribution gave the whole project its spiritual centre.

I had managed to convince several high-profile folks to let me put their names on my letterhead as honorary patrons, in hopes of swaying reluctant funders. I began courting Dr. David Suzuki in 2004. He politely demurred; he was having a hard enough time trying to retire as it was, he explained, but he would keep an eye out for me. We still hadn't met in person on June 29, 2004, when I attended a World Literacy fundraiser where he was the guest speaker. I introduced myself as the guy who had been

< Wedge from the trunk of the Golden Spruce, moments after it was cut for the guitar by Leo Gagnon on February 22, 2006

INTERVIEW WITH GEORGE RIZSANYI

Q. Where were you born and when did you come to Canada?

A. I was born in Hungary. My parents escaped during the Hungarian Revolution when I was one year old. We stayed in a refugee camp in Austria until they acquired passage on a ship out of Italy. I was two when we entered Halifax Harbour.

Q. When and how did you first get interested in guitars?

A. I was given a guitar at the age of four by a boarder my parents had taken in. I was curious about where the sound was made. As a child I thought there were magical creatures inside, and I think I still do.

Q. What makes a good guitar?

A. The musician. However, there are little secrets passed down from luthiers to their apprentices, and this information I can only give to another engaged in the craft.

continued on page 27 . . .

pestering him with the Six String Nation e-mails. His eyes lit up. "Jowi," he said, "I had an idea for your project. Have you heard of the Golden Spruce?" I hadn't. He told me the story of a wild albino tree on Haida Gwaii (a.k.a. the Queen Charlotte Islands)—a compelling, tragic, even magical tale. "I think," he said, "we can get a piece for your guitar."

The story of the Golden Spruce has almost as many layers as the 300-year-old tree has rings. A scientific curiosity and a tourist attraction, the Golden Spruce is sacred to the local Haida, who call it Kiidk'yaas. It has a special place in the foundation stories of the clans of Haida Gwaii. It became a symbolic fulcrum in the conflict between native land rights and the interests of industry and government. This led a disgruntled logging scout named Grant Hadwin to take a chainsaw to it in the middle of the night in January 1997. The Haida swore to leave Kiidk'yaas where it fell, letting the spirit and the substance of the tree return to the earth from which it had sprung.

Dr. Suzuki introduced me to some residents of Haida Gwaii who had a special interest in the life and afterlife of the

7

STRATFORD, ON
When Alec Guinness spoke the first lines of the first play produced by Ontario's Stratford Shakespeare Festival on July 13, 1953 ("Now is the winter of our discontent / Made glorious summer by this sun of York"), the venue was a humble canvas tent, from which this piece was taken. The tent was replaced by the current permanent facility in 1957.
COURTESY OF: Michael Langham, Don Shipley and the Stratford Shakespeare Festival, with help from John A. Miller

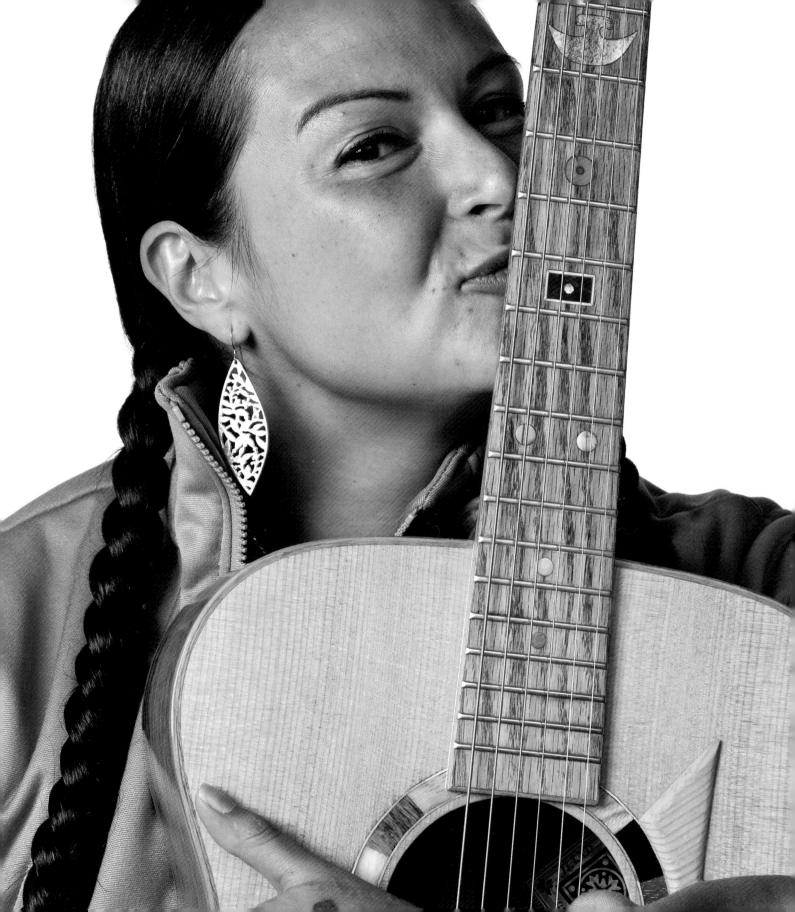

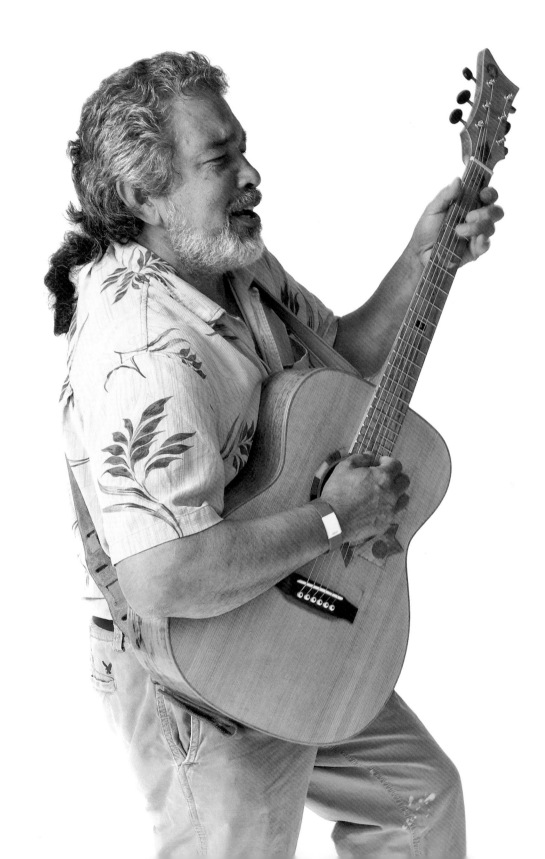

Guujaaw

tree, including David Phillips, a local community connector, and Guujaaw, president of the Council of the Haida Nation. With their help, and after many long phone conversations and a year and a half of advocacy, I booked tickets for myself, photographer Doug Nicholson, researcher Sid Bobb and luthier George Rizsanyi to stay at Phillips's Copper Beech House B&B in February 2006. CBC Radio and I shared the cost of bringing documentarist Geoff Siskind. After a couple years' debate within the community, it was finally agreed that the Six String Nation project would be a suitable and respectful use of a piece of the Golden Spruce. Leo Gagnon, a Haida carver from the town of Old Masset, stepped forward as the one to make the loving cut and help heal the hated Hadwin's carnage.

However, once we hit the ground in Haida Gwaii it seemed a little less solid under our feet than we had hoped. There was still some disagreement in the community, and Leo Gagnon told us that he wouldn't make the cut without the permission and presence of an elder, which would signal the community's final agreement. Leo explained that few and fewer elders were

Q. During the making of the Six String Nation guitar, you were in your workshop surrounded by bits of Canadian history. What was that like?

A. It was difficult analyzing all that information, organizing the visual information I was getting. Each piece created a montage on the movie screen of my mind.

Q. Do any particular pieces stand out for you as significant?

A. The Golden Spruce blew me away. All the pieces were very cool. Although some were quite smelly—the baleen and the moose shin made me gag a bit.

Q. What were your considerations in determining what type of guitar this would be?

A. I wanted this guitar to be able to stand the strain of so much energy, so many hands. I built it tough. I set the action at a level I thought could be handled by feather-soft hands as well as the gnarly and gristled. It was built for and by Canada, and one thing Canada and Canadians are—besides extremely gentle and understanding—is extremely durable and tough.

continued overleaf...

8

LUNENBURG, NS
Salvaged pew from St. John's Anglican Church. Built in 1754 and expanded in 1892, this Carpenter Gothic building was nearly destroyed by fire set by vandals in the early hours of November 1, 2001. COURTESY OF: St. John's Anglican Church

Q. What were the biggest challenges you faced in terms of design and materials?

A. Some pieces were so saturated with oil or foreign material that cleaning them was a challenge. The slate shingle, from the roof of the slaves' church, was very brittle and would come apart if I tried to carve it or shape it. So I turned it into black dust and used it as a topping for the handmade bridge pins.

Q. To what extent did the materials "speak" to you as you worked with them?

A. I became tuned in to my materials very early after finding out where they were from, what they were used for. One time in particular—and this is caught on film—I was cutting a piece on a table saw, which can be a very dangerous machine. This piece seemed to almost warn me that there was an evil little spirit lurking in it, and if I did not stop what I was doing I could be injured or hurt. So I listened and turned the machine off. Can you imagine, cutting through my fingers for national television?

Q. How was building this guitar different from other guitars you have made?

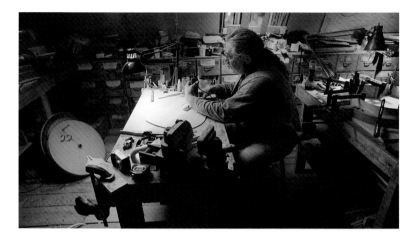

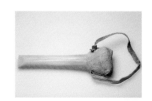

PATUANAK, SK
Moose shin. Singer-songwriter Don Freed has worked for many years with the youth in this northern Saskatchewan Dene community. Moose is a big part of life and culture there, and Don insisted that it was a great material for instruments—so we couldn't but take his recommendation. COURTESY OF: Don Freed and the community of Patuanak

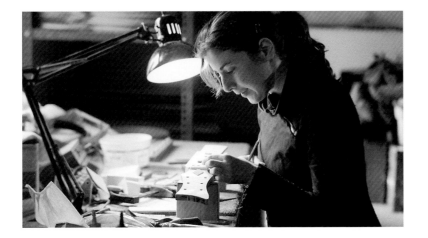

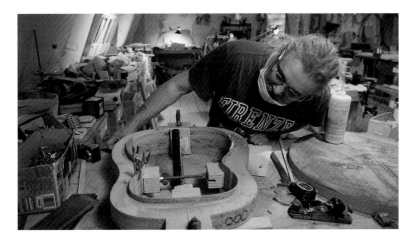

A. I felt that I owed it to each and every person to find a prominent and meaningful place for each piece. I think each piece does hold a unique and important spot in keeping this instrument together and representing all of us. We are all in that guitar.

Q. Who helped in the workshop?

A. My friend and past student Michael McConnell was always helpful morally. The film crew was awesome. And Jowi Taylor, of course, who helped glue in a few pieces. Sara Nasr helped with all the inlay work in the fretboard. She was masterful. I don't know if I could have finished on time without her.

Q. What was your feeling when you first heard the guitar played onstage on Canada Day 2006?

A. Very joyous. I almost broke down in tears. However, there was a camera in my face, so I contained my emotions.

Q. What artist would you most like to hear playing the guitar who has not yet played it?

A. Without any hesitation, Joni Mitchell. James Taylor, if he was Canadian. Perhaps we can make him an honorary Canadian.

10

TWILLINGATE, NL
Drawer from the lifeboat of the *Christmas Seal*. Built as U.S. Navy torpedo boat PT107, she was purchased by the Newfoundland Tuberculosis Association and converted into a floating X-ray clinic serving outport communities in Newfoundland and Labrador under the captainship of Peter Troake. She sank outside Halifax Harbour in 1976 after hitting a reef. COURTESY OF: Bud Thomas, with help from Herb Davis

BRITISH COLUMBIA

Volunteering for a reading of Dickens's *A Christmas Carol* for CBC took me to beautiful Rossland, B.C., in November 2004. Rossland is built on Red Mountain, an extinct volcano in the Monashee Range. Just down the mountain is the grittier mining town of Trail. Six String Nation was in the research stage at that point, and I asked my hosts if they had any ideas for historic pieces from the area. Red Mountain is the location of the famous Le Roi Gold Mine, so there was all that history, and then there was the famous Trail Smoke Eaters amateur hockey team, which translated gold mining into gold medals, representing Canada at the World Hockey Championships in Switzerland in 1939 and 1961 and going unbeaten in both tournaments. But Rossland was also the home of two of Canada's most storied ski champions: Kerrin Lee-Gartner and Nancy Greene.

I had practically grown up watching Nancy Greene on TV. To this day, I can't hear the word "Grenoble" without seeing her toque-topped face. For years she was the "It Girl" for Mars Bars. A provincial park near Rossland is named in her honour, and she was appointed to the Senate in 2008.

I called her Sun Peaks Resort near Kamloops and soon found myself talking to Canada's Female Athlete of the Twentieth Century, Nancy Greene-Raine. When I told her what I was trying to do, she instantly took to the idea. She knew that her brother John would have a handle on where all her stuff was, and sent him to scour the family basement. He soon came up with a ski she'd used in her early teens. Meanwhile, I dispatched a videographer named Nick Chevrefils from nearby Heffley Creek to do a little interview with Nancy about her contribution. When I got the tape a week later, there was Nancy declaring herself a citizen of the Six String Nation and playing air guitar on one of her childhood skis. She told me her son plays guitar for real, and I look forward to putting it in his hands at Sun Peaks so he can show her how it's really done—and I can thank her for being, in so many ways, a great sport.

11

ROSSLAND, BC
Piece of Nancy Greene's childhood ski. In 1968, Greene won gold (giant slalom) and silver (slalom) at the Winter Olympic Games in Grenoble, France. Combined with her record number of World Cup victories, that made her the most decorated ski racer in Canadian history and Canada's Female Athlete of the Twentieth Century. She currently runs the Sun Peaks Resort north of Kamloops, B.C.
COURTESY OF: Nancy Greene-Raine, with help from John Greene

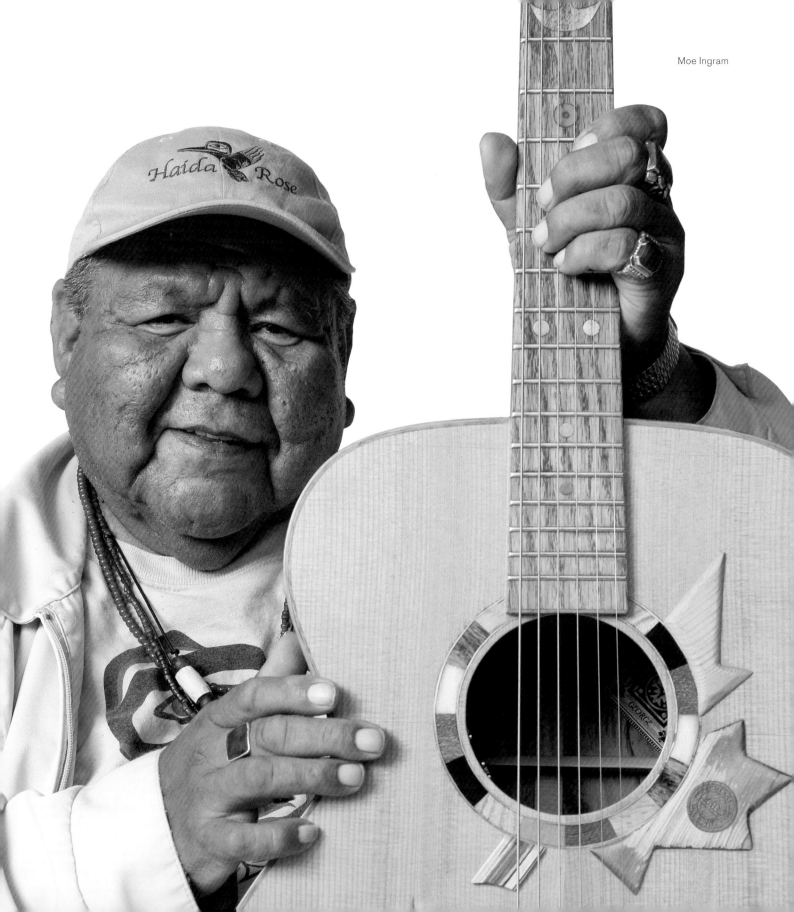
Moe Ingram

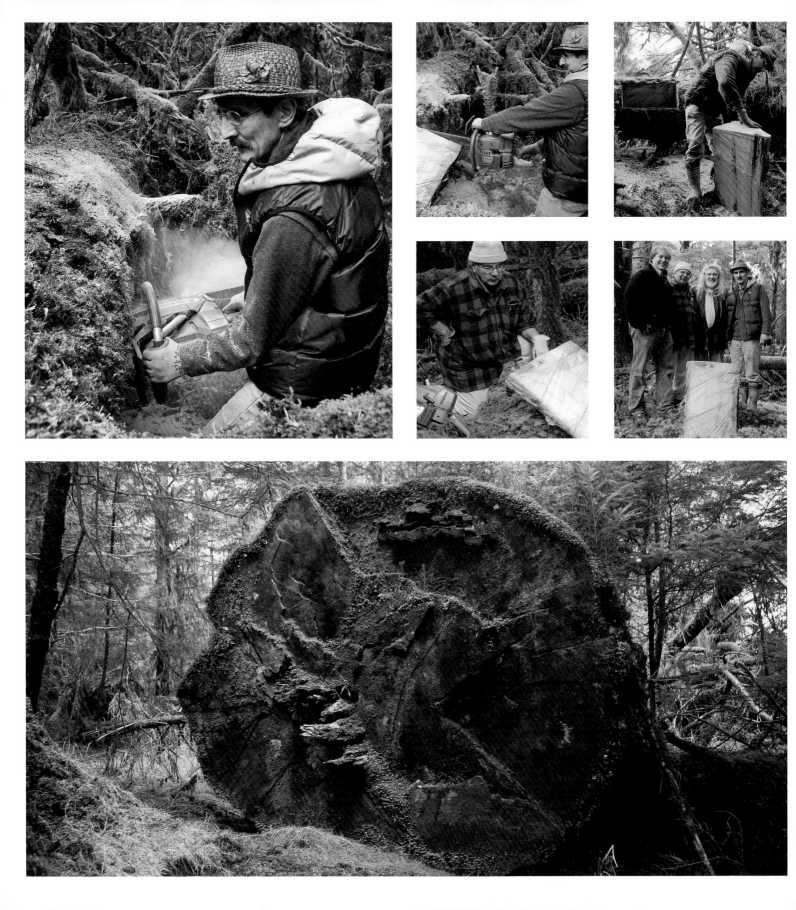

sturdy enough to make the trek to the Golden Spruce. And it was by no means certain that the wood, after nine years of lying on the forest floor, would not be rotted through. Finally, as is the case for just about anything on Haida Gwaii, the weather would be the final decider. We spent two days at the Copper Beech House, speaking to artists who came through, chatting up folks we met at the hair salon and Lucille Bell's Haida Rose Cafe, taking whatever encouragements Guujaaw had to offer and getting to know Leo Gagnon's dry sense of humour—and his wonderful cooking of ghow and black cod. With my heart in my mouth (and my credit cards at the max), I told Leo that whatever happened would be fine by me.

On February 21, the weather was clear enough for Leo to lead us out along the Golden Spruce Trail near Port Clements, where we stood on the bank of the Yakoun and could see a portion of the wrecked tree sprawled on the opposite bank. Part of me thought this might be as close as we'd ever get.

The following morning, Leo told us that elder Frank Collison had agreed to join us and, weather permitting, we would all go to the site around noon. As if by special provision, there was a break in the flurries and we all piled into a couple of tiny rental cars and headed out to the site. Leo brought a little punt that we carried down the trail—a hike of

12

NEAR PORT CLEMENTS, HAIDA GWAII, BC
The only wood ever taken from the legendary albino Sitka spruce tree known as Kiidk'yaas, or "The Golden Spruce." A natural wonder sacred to the Haida people, the tree was dealt a fatal cut by a misguided logging protester on January 22, 1997, and remained untouched until the cut for this project on February 22, 2006. COURTESY OF: the Haida community, with special thanks to Leo Gagnon, Frank Collison and Guujaaw. Thanks also to Dr. David Suzuki, Elois Yaxley and David Phillips.

SANDOR FIZLI (materials photographer)

I made the trip to George Rizsanyi's workshop—about an hour's drive from my home in Dartmouth—several times, and each time my excitement grew. My time at the shop would flow by faster than I wanted, as I documented each artifact that came in and then tried to catch it as it found its place in the guitar. Jowi had hired a video crew whom I would often cross paths with over the course of the build, but it was great for me because they left their specialty lights up in the shop for the duration. I was in photographer's heaven. It felt as if I might as well have been in another century: a wood shop full of luthier's tools with nice, warm lighting and pieces of Canadian history strewn about the shop waiting to be shaped into a guitar by a master craftsman: Rocket Richard's Stanley Cup ring in a box on the finishing table, a piece of the Golden Spruce of Haida Gwaii leaning against the table saw, Pierre Trudeau's canoe paddle laying next to the belt sander.

We often worked into the evening. George would study a piece, feel it over with his hands, smell it, get some feeling from it and then decide how he would work with it. I shot with available light, trying hard to capture and translate the feeling that was in the room at the time. We were surrounded by history and at the same time we were making history. It was an amazing feeling and an experience I am happy to have as a memory for the rest of my life.

George Rizsanyi in his workshop in Pinehurst, NS >

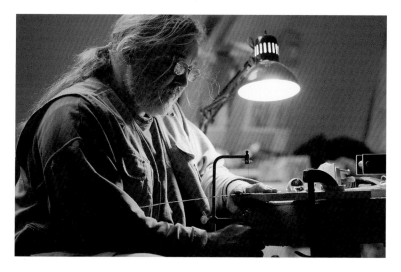

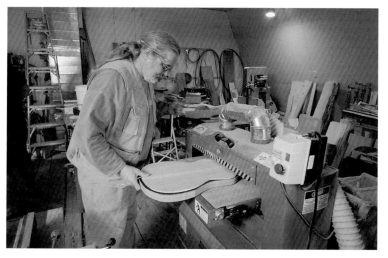
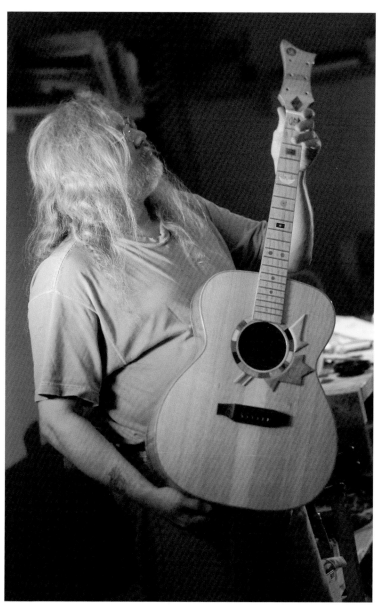
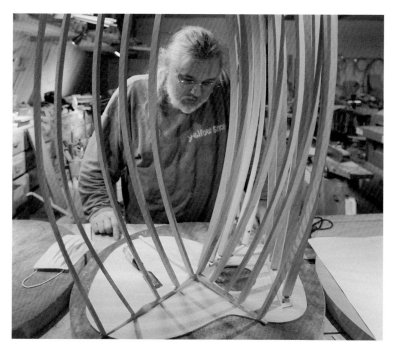

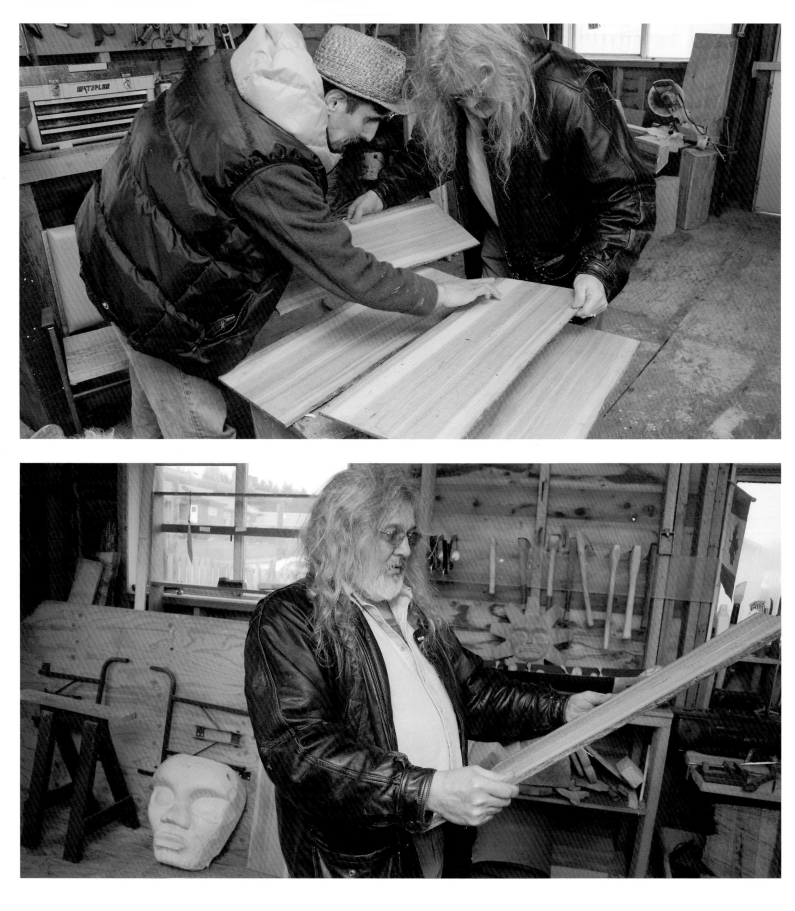

< George Rizsanyi with Leo Gagnon in Leo's workshop in Old Masset, Haida Gwaii, BC

maybe forty minutes. At the river, we descended the muddy banks and pole-barged to the other side in shifts.

After we'd walked the cathedral-like trail of massive trees, seeing the giant stump and fallen carnage of the Golden Spruce was especially shocking. Sid Bobb made an offering of tobacco at the stump. We moved up the length of the tree as Leo looked for clues as to where to make the cut. Almost by divination, he zeroed in on a spot about two-thirds of the way up. When the tree had fallen, some of its upper branches had snapped off partway, acting almost as legs to keep the tree off the ground along this section and perhaps slowing the otherwise inevitable rot. After a few more prayers and words from Frank Collison, Leo fired up the chainsaw and solemnly began cutting. With the deft work of his saw and an axe used as a lever—and with help from me and George and Sid—we lifted the wedge out of the tree and placed it on the forest floor. For what seemed an eternity, we stared in silence at this magnificent chunk of wood. It was perfect. With one look, George knew that we had our guitar top.

But guitars weren't much on our minds at that instant. We were all still reeling from the impact of what we had just done, as if we ourselves had each been cut in our own way. It was almost as if we were emerging

13 SYDNEY, CAPE BRETON, NS
Steel rail sample from Sydney Steel, now defunct but once the heart of a thriving steel and coal industry in this part of Nova Scotia. COURTESY OF: Carolee Boutilier

from a dream, dizzy and disoriented. Frank launched into the story of the young boy instructed by his grandfather to embark on a search for a new home for the Haida village. When he disobeyed his grandfather's command not to look back, the boy found himself rooted to the ground and immortalized as Kiidk'yaas. Frank's rendering of the tale rooted us all in that moment, and became part of the creation myth of the guitar.

I know it was a tough decision for the community, but the idea ultimately prevailed that this important part of their story could be amplified by making this contribution. That piece of the Golden Spruce is now the face this guitar shows to the world. The wood used for a guitar top is fundamental to the character and tone of a guitar, so part of the measure of success would be how much the community saw and heard itself reflected when we returned with a completed guitar. We did that in August 2008, when Doug and I took our set up to the Edge of the World Festival. In the performances onstage and in the portrait sessions offstage, we felt a resonating embrace. It was a true homecoming. Guujaaw summed it up in the closing remarks of the festival: "I don't think I even imagined what an amazing effect this guitar would have on this community. This project has accomplished something no politician could ever do. Thanks for bringing it back to Haida Gwaii."

14

NIAGARA FALLS, ON
Wooden nickel from *Maid of the Mist II*. Starting in 1854, the *Maid of the Mist* carried tourists to the base of the Bridal Veil (U.S.) and Horseshoe (Canadian) sides of Niagara Falls. In the spring of 1955, *Maid of the Mist II* and *III* burned in dry dock during pre-launch maintenance. Enough wood was salvaged from *MMII* to make 38,000 wooden nickels, which were sold to raise funds to build the next *Maid of the Mist*. COURTESY OF: Tim Ruddy, *Maid of the Mist*

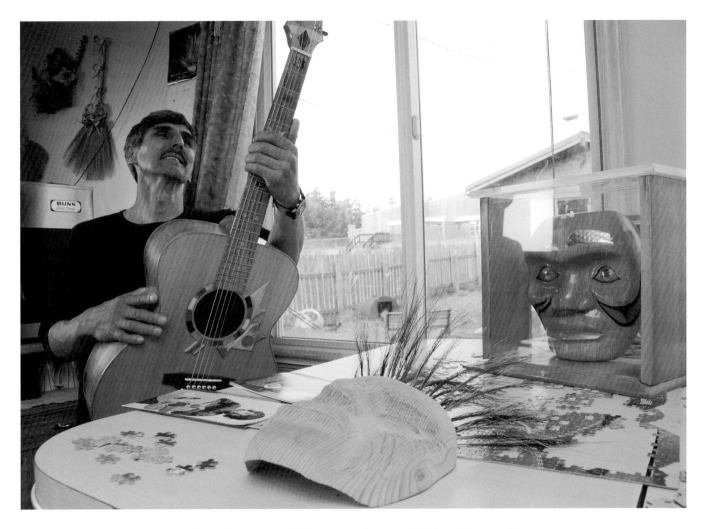

Carver Leo Gagnon with Voyageur and his mask of Kiidk'yaas (foreground),
which was made from the same wedge of wood used in the guitar

15

DAWSON CITY, YK
Floor beam from the cabin of American author Jack London
(*The Call of the Wild*, *White Fang*). His time in the Yukon during
the Gold Rush inspired many of his best-loved stories. The
main building of the cabin was relocated to his California
birthplace, but the floor remained in Dawson, where a replica
was built. COURTESY OF: Mike Edwards, Yukon Tourism and Culture

MANITOBA

In March 2006, I was invited to canvass listeners of CBC Radio's afternoon show in Winnipeg for morsels to include in the project. Before I was off the air, Philippe Mailhot, director of the St. Boniface Museum, was on the phone saying he wanted to be part of it.

Philippe is evangelical about his beloved museum, but the building really speaks for itself. Built between 1846 and 1851 as the Convent of the Grey Nuns of Montreal, it was the first building in Winnipeg–St. Boniface and it remains North America's largest oak log-frame structure. Metis leader Louis Riel went to school there briefly as a teen. Today, it houses a collection of artifacts from Riel's time, including the crude coffin in which he was first buried after his execution. In that sense, the building is very much at the heart of the history of the community and the province. But it's also at the heart of the city's geography: the meeting of the Red and Assiniboine rivers. It was the inevitable and repeated flooding of those rivers that invited fungus into the white oak beams and, as they dried out and re-flooded, created remarkable spalting patterns in the wood. Philippe donated a section of one of these beams. The moment George received this wood, with its tiger-like appearance, he knew exactly how to put it to use in various places—most strikingly (and most untypically for oak) as the back of the guitar.

On our first return trip to Winnipeg with the completed guitar in July 2006, Philippe and I organized an intimate concert event featuring the guitar in the museum's chapel. There, a young Metis artist named Serge Carrière played a song he'd written for his great-great-uncle, who had fought alongside Riel at the Battle of Batoche. There was not a dry eye in the house.

Two weeks later, in a gazebo on the east bank of the Yukon River at the Dawson City Music Festival, John K. Samson took up the guitar and told the crowd, "The back and sides of this guitar are made from a building closely tied to Louis Riel. Louis had a complicated relationship with his hometown. So do I." With that, he launched into his brilliant Weakerthans song "One Great City," a backhanded love song to Winnipeg if ever there was one.

16

ST. BONIFACE (WINNIPEG), MB
Spalted oak from the St. Boniface Museum. Built in 1846 as the Convent of the Grey Nuns of Montreal, it is Winnipeg's oldest building and the largest oak timber frame building in North America. It has served as a convent, orphanage, hospital, school and seniors' home. Louis Riel, the Metis leader and Father of Manitoba, briefly went to school there, where his sister was a novice. COURTESY OF: Philippe Mailhot, Museum Director

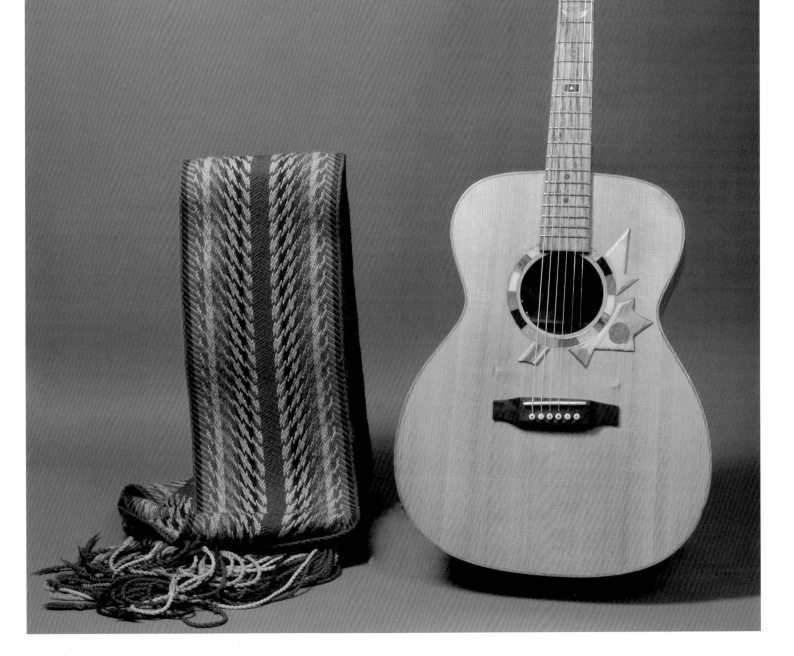

Voyageur with Louis Riel's recently recovered *ceinture fléchée* (sash) at the St. Boniface Museum, Winnipeg, MB

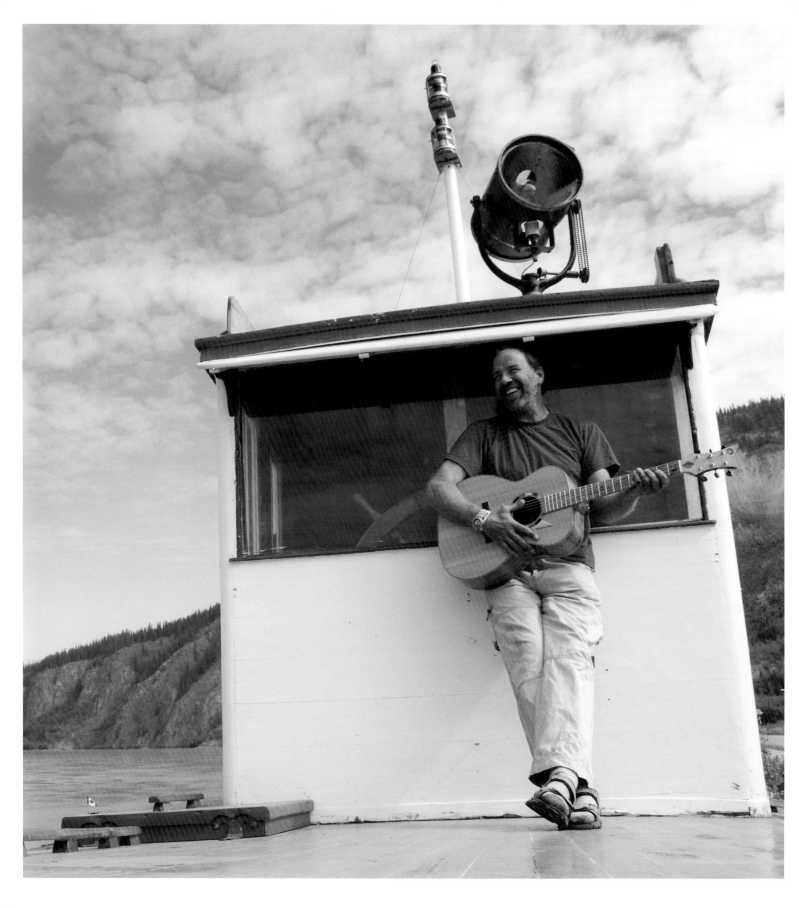

E A **D** G B E

DEBUT

Online comments in response to the November 2005 *Globe* article were all positive but one, which called the very idea of a guitar made from fragments of Canadian history "the ultimate in cheese." Part of me feared that might be true. I'd done everything I could to make sure that the pieces included a mix of well-known and unknown histories, touchstones and points of departure, items of commonality and of controversy. I was confident that the pieces we got were the right ones. In order for it not to be cheesy, though, it would have to be beautiful to look at and listen to. It would have to be accepted as an instrument, not just as an object.

George Rizsanyi had been tapping, humming and singing into the wood at various stages of construction, testing for tones and resonances, but he first strung it up as a proper guitar on June 14, 2006. I joined him and the film crew on June 15 (my birthday, coincidentally) and all of us

< Aboard the *Yukon Rose* with the vessel's
current owner, Marc Johnson

took a strum. It was remarkable to feel the weight of what had for eleven years been nothing but words and dreams and scraps of stuff from across the country. I had held plenty of guitars before, but this seemed so solid, so substantial. I could feel the notes and harmonics of my rudimentary chords pushing from within the guitar, straight into my solar plexus. It was as if the sound was as solid as the instrument itself.

The following day, two fine musicians came down to Pinehurst to put the guitar through a preliminary trial. Roger Howse is a bluesman from St. John's, Newfoundland. Dave MacIsaac, from Cape Breton, Nova Scotia, is a fiddler and guitarist in the Celtic tradition. St. John's and Cape Breton are arguably Canada's most musical places, so this seemed like the right duo to put the guitar through its paces. In the narrow space of George's finishing room, we gathered to hear Roger and Dave give the guitar its first breath of music. This happened in front of a total of ten people.

On June 28, the guitar arrived in Ottawa for Canada Day rehearsals on Parliament Hill. On June 29, Colin James played it for a cluster of press gathered at the edge of the stage. Later that day, just before an interview with Jian Ghomeshi for CBC Radio's *Sounds Like Canada* at the CBC studios on Sparks Street, guitarist Andy Sheppard wandered by and we pulled him in to the booth for an on-air demonstration. On the morning of July 1,

17

TORONTO, ON
Seat 69 from the gallery section of Massey Hall. The "Grand Old Lady of Shuter Street" was built in 1894. At one time or another it has hosted everything from union meetings and boxing matches to performances by the likes of Enrico Caruso, Glenn Gould, Neil Young and Arcade Fire, to speeches by everyone from Winston Churchill to the Dalai Lama. COURTESY OF: Massey Hall and Roy Thomson Hall, with help from Charlie Cutts, Jesse Kumagai and Douglas Gardner

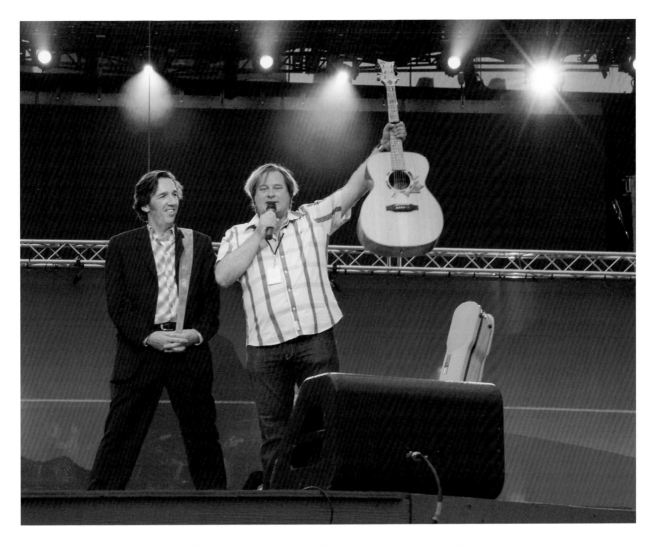

The debut moment arrives on Canada Day 2006, Parliament Hill

18

KUUJJUAQ, NUNAVIK, QC
Caribou antler and soapstone. An ornamental ulu (women's knife) carved by artist Charlene Watt. COURTESY OF: Charlene Watt, with thanks to Richard Murdoch at FCNQ, and Elisapie Isaac

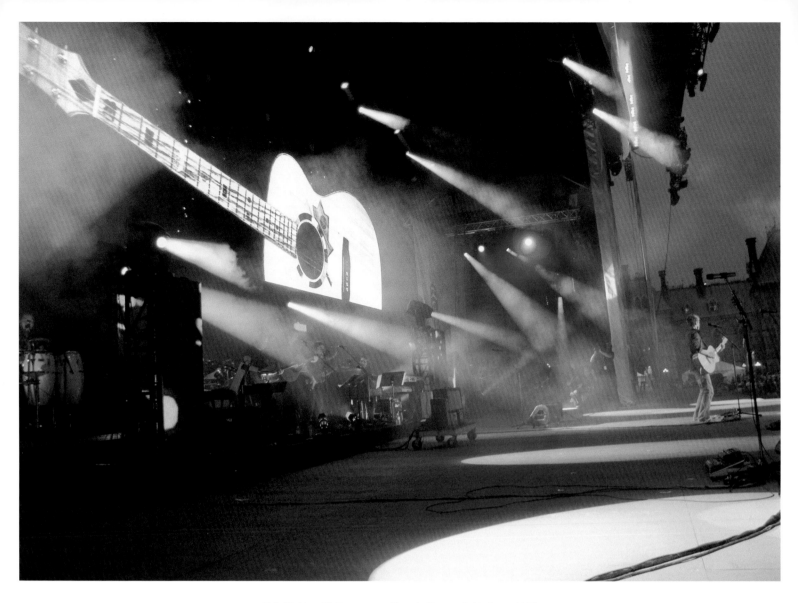

Kyle Riabko with Voyageur on Canada Day 2006, Parliament Hill

19

NAIN, NL

Labradorite, an iridescent blue feldspar mineral found abundantly on Paul Island, near Nain. Inuit legend holds that the northern lights were once trapped in the stone until freed by a hunter. The blue remained.

COURTESY OF: Henry Lyall, with help from Chris Kearney

Saskatchewan's Jöel Fafard—an award-winning finger-style guitarist and son of the great sculptor and painter Joe Fafard—accompanied us to a National Capital Commission brunch, where he played for the event sponsors. On the afternoon of July 1, at a songwriter's circle in Major's Hill Park called "Songs from the Six String Nation," I handed the guitar first to Colin Linden, Canadian guitar legend and Nashville insider. I'd seen his first public performance, at Ranchdale Public School in Don Mills, Ontario, when I was in grade three and he was in grade six.

And on the evening of July 1, I had one of my dreams come true. Practically since the day of conception, I had imagined that the first song played on my then-imaginary guitar would be Stephen Fearing's "The Longest Road," a song I'd seen Stephen do live a number of times. It's a song about leaving Canada, but every time I heard it my heart swelled at the chorus, which is infused with the sense of scope and landscape and movement that the very word "Canada" seems to evoke. Seeing it performed in concert, I knew that thousands of others felt the same way. And it certainly seemed to hold true as Stephen played "The Longest Road" to kick off the Canada Day evening concert on Parliament Hill, officially introducing the guitar to the country. That performance took place in front of eighty thousand people.

20

GARDENTON, MB
Wood from St. Michael's Orthodox Ukrainian Church. Completed in 1899, it is the oldest Orthodox Ukrainian church in Canada.
COURTESY OF: Gerard Machnee

THE LONGEST ROAD (LYRICS)
Stephen Fearing

I'm standing at a window, I'm pressed against the past
I'm looking on in black and white, through the eyes of photographs
And I'm falling into faces, cultivated smiles
Two-dimensional, Je me souviens Canada

Out of Gastown in the morning, on a train in '69
Into the arc-weld of the rising sun, we left the coast behind
And the wheels rolling a rhythm, and I heard in them for the first time
The endless song of travelling out of Canada

Oh Canada, the longest road I've known
Paved with the kind of broken hearts that lead to broken homes
Looking backwards I remember the cracks in all the paving stones
And the distances I've travelled out of Canada

Through the dog days of the prairies, the boundless sky above our heads
My stepfather looked for Mounties in the streets of Winnipeg
And he told them that my mother's love had stole his heart away
And we all stood there, posed for Polaroids of Canada

Oh Canada, the longest road I've known
Paved with the kind of broken hearts that lead to broken homes
Looking backwards I remember the cracks in all the paving stones
And the distances I've travelled out of Canada

I awoke wrapped in my mother's arms on the docks of Montreal
The ships lit like Christmas and the moon a swollen ball
And when a sailor spoke of England, I'd never felt so small

I waited until the ocean turned from emerald to grey
The wind threshed the water and washed our wake away
And the seagulls blew like words back to the mouth of the St. Lawrence
As we sailed out on the *Empress of Canada*

Oh Canada, the longest road I've known
Paved with the kind of broken hearts that lead to broken homes
Looking backwards I remember the cracks in all the paving stones
And the distances I've travelled out of Canada
The first country of my youth
My heart was ever drawn to you like a tongue to a broken tooth
In a world where everyone was always leaving
I was trying to keep my fingertips on Canada

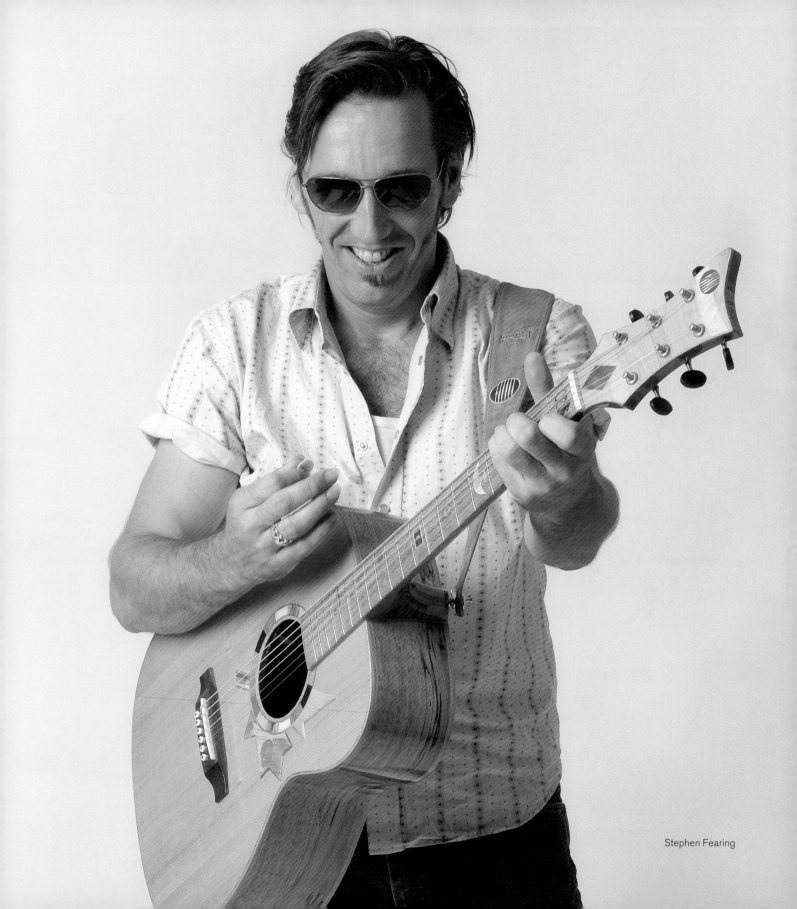

Stephen Fearing

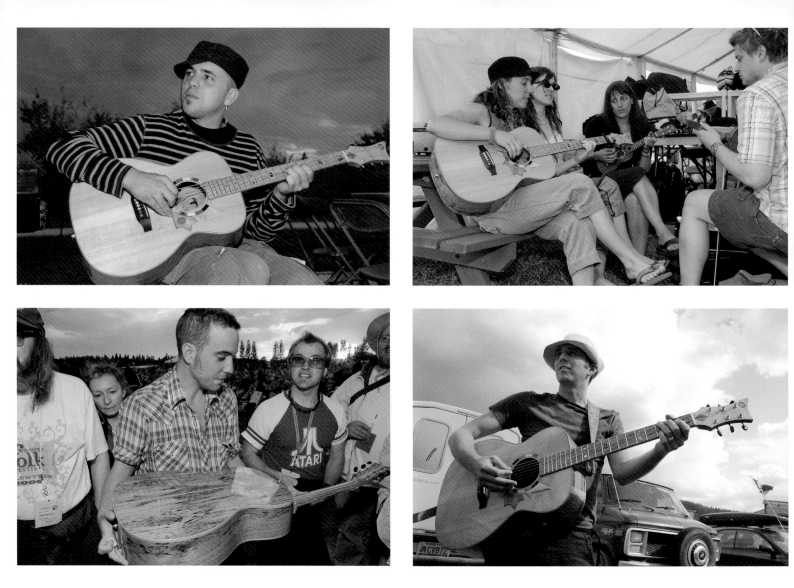

Clockwise from top left: Hawksley Workman, The Wailin' Jennys,
John K. Samson and Justin Rutledge play Voyageur backstage at various festivals

21

LUNENBURG, NS
Decking from the *Bluenose II*. Launched in 1963, the ship was built partly from material that had been kept on hand to repair Canada's most famous racing schooner, *Bluenose I*, until it sank off a reef in Haiti in 1946.

COURTESY OF: Lex McKay, Senator Wilfred Moore and the Bluenose II Preservation Trust

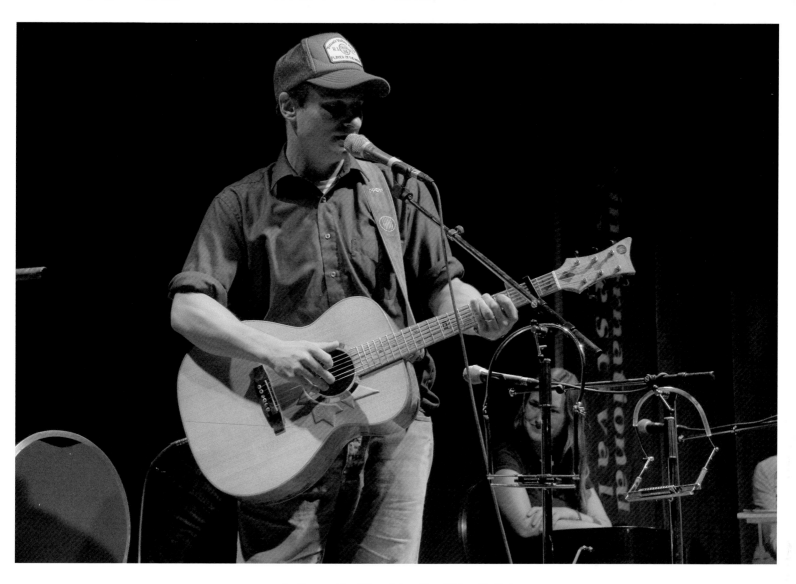

Jim Bryson at the Ottawa International Writers Festival

22

MONTREAL, QC
Bagel shibba—the long paddle used to carry bagels in and out of
the brick ovens at the legendary Fairmount bakery, Montreal's first,
founded by Isadore Shlafman in 1919. COURTESY OF: Irwin Shlafman

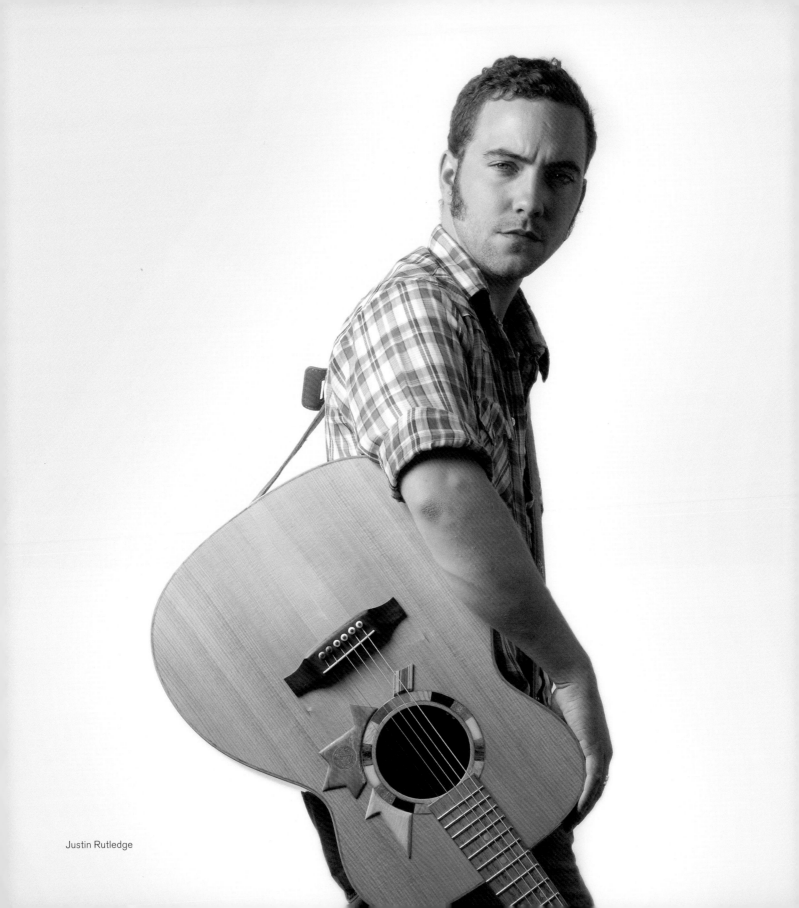

Justin Rutledge

JUSTIN RUTLEDGE

Until the age of five or so, I thought I was American. I was shocked when my mother broke the news that we lived in a place called Canada and that we were, in fact, what people around the world called Canadians. I didn't know what to make of this, but I reluctantly accepted what was then a harsh and cruel reality. You see, I—like most of us—was raised on a steady American diet: G.I. Joe, Disney World commercials and all the comics I read had me thoroughly believing that Toronto was somewhere in Illinois or New York State. I felt like I'd been had. The years passed and I warmed up to being a Canadian. I began to read books about our country. I listened to music written by Canadians. By the age of sixteen you could say I was quite smitten with Canada: I longed for the day when I could ride the same rails the Group of Seven rode, employ my thumb on Maritime highways, spend a night underneath an open prairie sky like a bedraggled Huck Finn who'd lost the map, or name myself after one of those mountains in the navy blue west. I wanted so madly to connect with my country. I would come to her as a pilgrim, for I thought she was beautiful.

I wanted to connect with Canada, and I would later f ind this connection in the Six String Nation guitar. To hold the Six String Nation guitar is to hold our country. It stretches coast to coast, unadulterated by borders, and abandons all political and regional rhetoric in order to connect with the people of Canada in a voice we all can understand: music.

I was lucky enough to meet Jowi Taylor when I began my residency at the Cameron House in downtown Toronto. I was luckier still to be asked to play his guitar while standing on top of the bar one evening while everyone sang along to a song I had written, and with each strum it was as though I moved deeper and deeper into the fabric of our country. The guitar, much like Canada, consists of an array of seemingly incongruous artifacts, yet comes together to create something harmonious and absolute. One can feel distance and history in the wood. It surely is a powerful thing for me to play a C chord and feel as though I've just been somewhere else, to a shoreline I've never seen, but seem to somehow understand. As a musician, I've been able to see many of the places of Canada I initially longed to see. I am often sick with wonder. But even though there are still parts of this country my eyes will never know, I feel that somehow I've already been there in some chord I've struck on the Six String Nation guitar.

Since then, Voyageur has passed through the hands of hundreds upon hundreds of musicians from all across Canada in all kinds of settings and stages. Bruce Cockburn played a solo serenade in the dressing room at the Winnipeg Folk Festival; Amy Millan and Tony Dekker played it on a sunny Saturday afternoon at Harbourfront in Toronto; Feist played a tune backstage in Vancouver; Corb Lund played it at the Hillside Festival in Guelph; Stompin' Tom Connors played it in his rec room; Gordon Lightfoot played it at his seventieth birthday party; Ron Sexsmith played it in a duet with Andy Kim at Hugh's Room; Amelia Curran played it at the legendary Ship Inn in St. John's, and Justin Rutledge at the legendary Horseshoe Tavern in Toronto; John K. Samson played it on the banks of the Yukon River in Dawson City; all the members of the African Guitar Summit have played it, together and separately, in different parts of the country; Bill Bourne, Matt Masters and Ana Miura played it on *Breakfast Television* in Edmonton, Calgary and Ottawa respectively; Genticorum played it once in David Neale's living room and once in the Grand Hall of the Museum of Civilization; Lynn Miles played it on half a dozen occasions including in a couple of very cozy house concerts in the dead of an Ottawa winter.

Voyageur's strings have rung with jazz and pop and Celtic and country and reggae and folk and blues and soukous and soul and classical and

23 CONCEPTION BAY, NL
Red ochre. The now-extinct Beothuk people were the original inhabitants of Newfoundland. Their practice of treating their skin with red ochre, a natural pigment made from hydrated iron oxide clay, led early European explorers to call them "Red Indians." COURTESY OF: Tim Rast

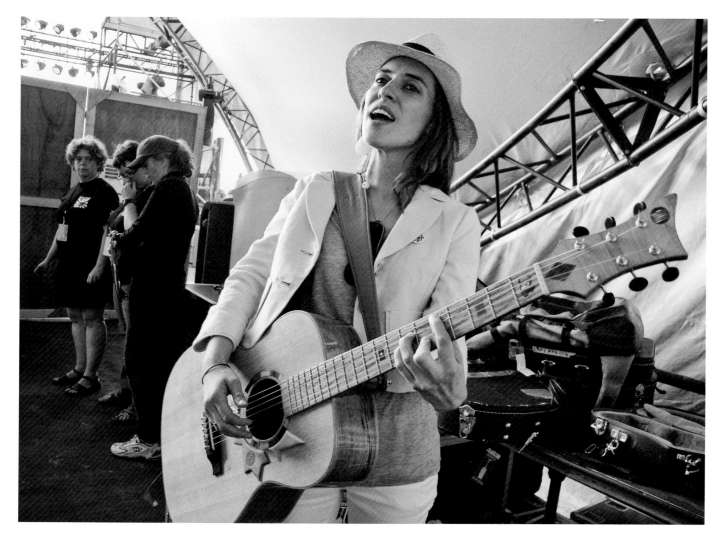

Feist backstage at the Vancouver Folk Music Festival in July 2006

24

OTTAWA, ON

Fabric from Karen's Kain's costume as Princess Florine in
The Sleeping Beauty (1972). COURTESY OF: Karen Kain and The National
Ballet of Canada Archives, with help from Pam Steele and Susan Rutledge

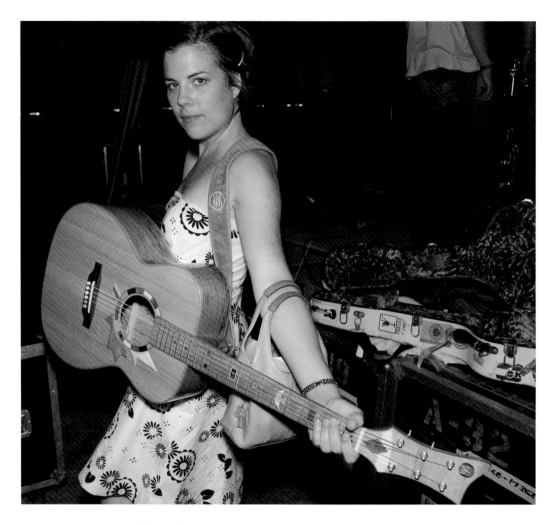

Roxanne Potvin accessorizing at the Hillside Festival, Guelph, ON

25

EDMONTON, AB

Part of a hockey stick from the Great One, Wayne Gretzky. Originally from Brantford, Ontario, he played briefly for the Indianapolis Racers of the WHA before signing with the Edmonton Oilers, the team most closely associated with his career. He subsequently played for the L.A. Kings, the St. Louis Blues and the New York Rangers. Currently coach and co-owner of the Phoenix Coyotes, he is called by many the greatest player the game has ever seen. His number, 99, is the only number ever to have been retired for all teams.

COURTESY OF: Wayne Gretzky

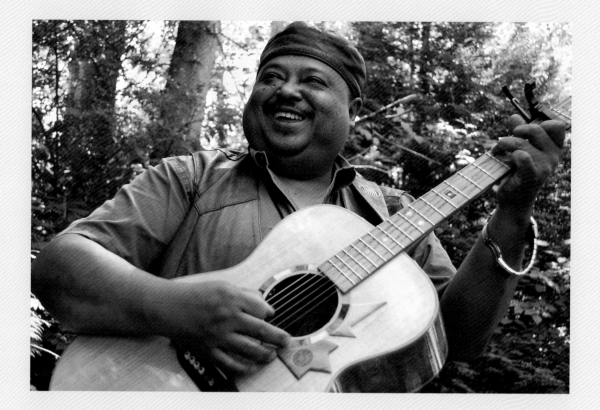

MADAGASCAR SLIM

My name is Randriamananjara Radofa Besata Jean Longin, a.k.a. Madagascar Slim, a Canadian originally from (you guessed it) Madagascar. I had the pleasure, the privilege and the honour to play the Six String Nation guitar. It probably is the only guitar I've ever played that felt and sounded better than my Taylor. The workmanship was exquisite, and the realization of holding in one's hands an instrument with all those historic landmarks of Canadian history was a powerful and inspiring feeling.

Jowi and I worked together many times over the years, or sometimes we'd just meet and talk in Kensington Market, so I feel like the idea of this guitar has been with me for many years. He invited me to play it long before it even existed, so I had that anticipation—even if sometimes it felt like it would never come. When I finally played it at the Vancouver Folk Festival, it was an emotional moment that brought tears to the eyes of both of us!

It is a great guitar, and the only problem with it is that I cannot afford to buy it.

Heather McLeod onstage at Summerfolk, Owen Sound, ON >

finger-style and shanties and samba and hip hop and all kinds of experiments in between. Usually, George Rizsanyi is asked to make a particular kind of guitar for particular clients. But the point of Voyageur is that there are so many perspectives on what it means to be a Canadian; this guitar should be capable of giving voice to any kind of expression. That's a tall order. A guitar is a personal thing. A musician might have a dozen guitars and reserve one for just a couple of songs in his or her repertoire. But Voyageur is, by design, a generous instrument that transcends all kinds of cultural and musical barriers.

I'm often asked "Why a guitar? Why not a fiddle or a canoe or something else?" And I always say: "Put ten Canadians in your mind who have helped to define Canadian cultural identity to ourselves and the world. I'll bet half of them are holding guitars." Songwriting is something that Canadians do well. From its origins in the Middle East and Spain, the guitar has found a natural home in our varied Canadian landscapes. It is our instrument. And this one is part of all of us.

26

SAINT-ARMAND, QC
Slate from the roof of the "Chapel at Nigger Rock." During the Civil War, an American loyalist named Philip Luke crossed the border into what is now the Eastern Townships of Quebec, accompanied by six slaves he had inherited from his mother. They remained slaves in this new land, and they and others were buried in what is now private property in a plot called "Nigger Rock" next to a farmer's field. Although it is disputed, a building at the opposite side of the field is believed to have been built by slaves as a small chapel. COURTESY OF: Hank Avery

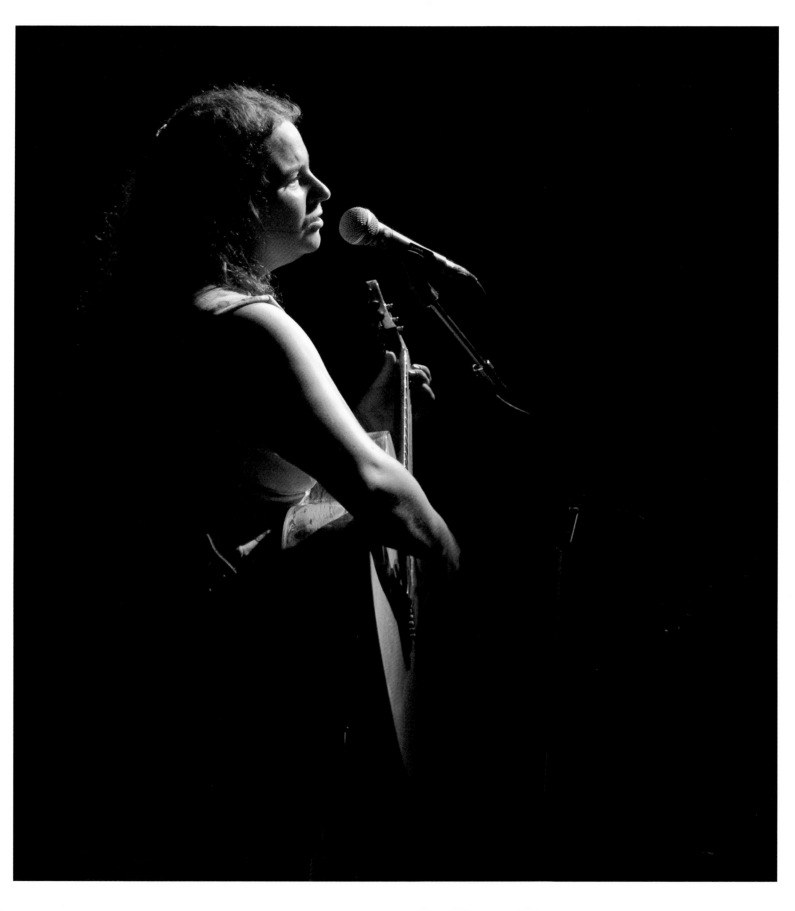

Actors bringing to life the star-crossed legends Gabriel and Evangeline of the Acadians' Grand Dérangement

NEW BRUNSWICK

During the Atlantic leg of our inaugural tour, we travelled all the way up the east coast of New Brunswick for Le Festival acadien de Caraquet. New Brunswick is home to the largest number of Acadians who returned to Atlantic Canada following the *Grand Dérangement* of 1755. The community now numbers about 380,000, and Caraquet is its cultural hub (and was declared Canada's Cultural Capital for 2003 and 2009). The story of the Acadians, I think, is deeply resonant for many Canadians both English and French. It was a case of domestic "ethnic cleansing" against a people whose principal crime was refusing to take up arms. It's the story told in Longfellow's epic poem *Evangeline* and The Band's "Acadian Driftwood."

An international touring multimedia show out of New Brunswick called "Ode à l'Acadie" was in Caraquet for the festival. It tells the same story through a whole bunch of songs by Zachary Richard, Edith Butler, Lennie Gallant, Ronald Bourgeois, Marie-Jo Therio and others. The cast consists of seven absurdly talented young performers led by musical director Isabelle Thériault. We met them an hour or so before their matinee and they gathered around the guitar and gawked, like most people, at Maurice Richard's Stanley Cup ring, Pierre Trudeau's paddle etc. When I asked if they'd like to play it, I could see them eyeing each other as they responded, "Is there anything Acadian in that guitar?" I'm sure they expected the answer no. I came back: "That cross brace is from the first dwelling on PEI, built by the Acadians Doucet and Gaudet in 1768, and the bridge here is made from a piece of the *Machault*, the French frigate found in the mud of the Restigouche River near Atholville, two hundred kilometres west of here down Chaleur Bay." Even if my eyes had been closed, I'm sure I would have felt the beam of their collective smile. Isabelle took the guitar and the cast gathered around her for a gorgeous song about the coming together of the Acadians, and then François Émond asked if he could play it during the show. This had been my dream—that wherever I might take this guitar in Canada, people would feel it had, in some way, come home.

27

RUSTICO, PEI
Wood from the house built in early Acadian vernacular style in 1768 by Jean Doucet and his wife, Marguerite Gaudet. It may be the oldest dwelling on all of PEI. COURTESY OF: Bobby Doucet and Lennie Gallant

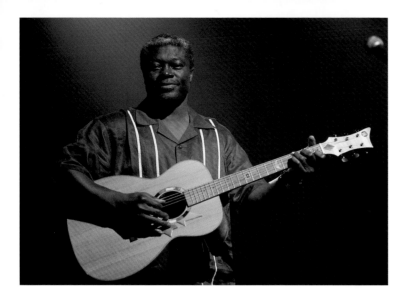
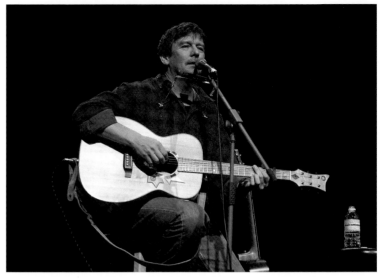
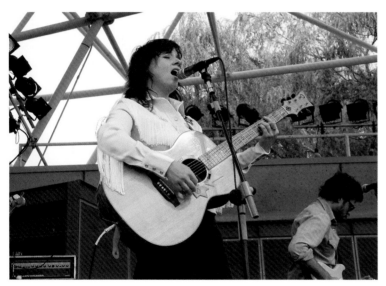
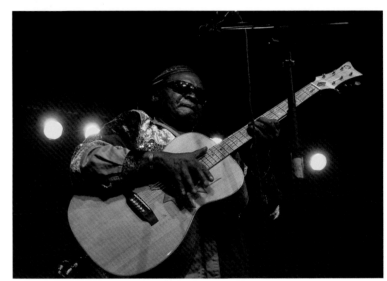
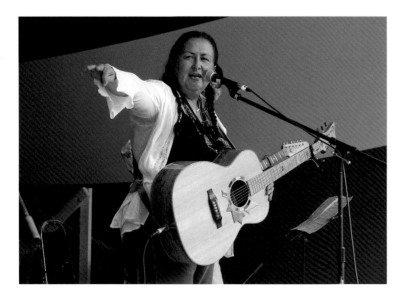
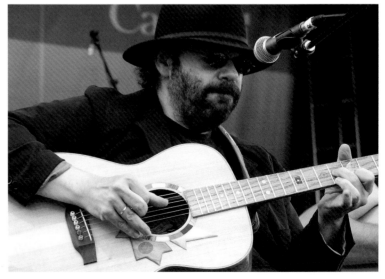

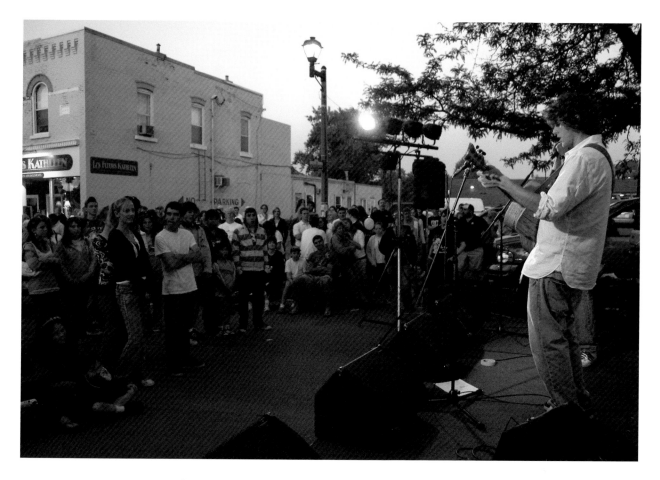

∧ Onstage at the street fair celebrating the sesquicentennial of Milton, ON

< Clockwise from top left: Pa Joe, Lennie Gallant, Jeik Loksa, Colin Linden, Sandy Scofield, Amy Millan

COBALT, ON

Silver from the Beaver Mine. The legend goes that in 1903 a railroad black-smith named Fred LaRose threw his hammer at a fox and accidentally discovered the world's richest vein of silver. One hundred mines sprang up, and Cobalt remained a boom town until the great stock market crash of 1929, generating more wealth than the Klondike. In 2001, Cobalt was named "Ontario's Most Historic Town" by a panel of judges on TVOntario's *Studio* 2 for its role in determining Ontario's history and economy.

COURTESY OF: Armand Cote, with help from Helen Culhane and Charlie Angus

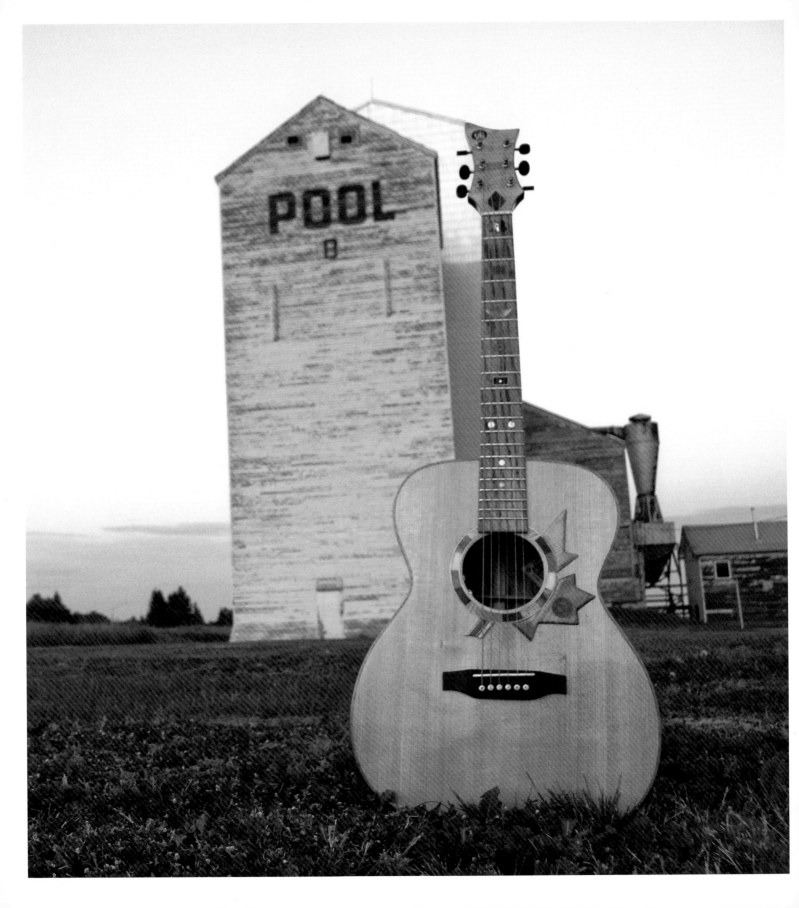

E A D **G** B E

THE LONGEST ROAD

LEARNED A TREMENDOUS AMOUNT FROM this project. But it wasn't until after the guitar's debut on Canada Day 2006 that I realized it had changed my way of thinking.

There on Parliament Hill, and for months afterward, people would congratulate me on having "done" the project. So much work, so much struggle, so much heartbreak and so much debt had gone into gathering the pieces, having them built into a gorgeous guitar and then introducing that guitar to the country in such a spectacular fashion. Certainly I had some sense of relief and accomplishment, but it didn't for a moment feel like completion. Everything up until that day felt like an introduction to the journey that was about to begin. If I was Carlo Collodi, George Rizsanyi was Geppetto, the guitar was Pinocchio and the musicians were a legion of blue fairies bringing it to life. And now it would need to have adventures, to meet people, to develop a personality, to become a "real

< Prairie homecoming in Verigin, SK

boy." I suppose that in some ways I was also Jiminy Cricket: I would have to become the conscience of the guitar, guide it on its travels. And this was the real test not only of the guitar but of myself, challenging my own assumptions about Canada every time we touched down in a new part of the country.

The project was inspired by the notion of getting Canadians to embrace a bigger, broader, more diverse, more nuanced picture of themselves—to accept Canada's clichés as charming parts, but certainly not the sum, of our collective identity; to feel that the character of their community was part of the national character whether it made the history books or not. To do that, I would have to get people to embrace the guitar both literally and figuratively. In the comments of musicians at festivals, concert halls and campfires, in the brochures we distributed at events, in the conversations I had in festival tents from Dawson City to St. John's, Haida Gwaii to Happy Valley—Goose Bay, in the messages that came to the website, I felt reflected back at me the same sense of pride and discovery that had marked my own process in bringing the project together. People responded equally to the "big ticket" celebrity items in the guitar, to the pieces that connected to their own communities, and to the pieces that revealed some story from some part of the country they didn't know before. It has been

29

PINETTE, PEI
In June 1997, Tyler Aspin began work on what would become a thirty-five-foot-tall sculpture called *The Canada Tree*. Like the Six String Nation guitar, it was the manifestation of a belief in the power of the collective stories of the people and regions of Canada to say something about who we are as a people. Tyler died on August 17, 2001, at his cottage in Quebec. He was 31 years old. COURTESY OF: John and Linda Aspin

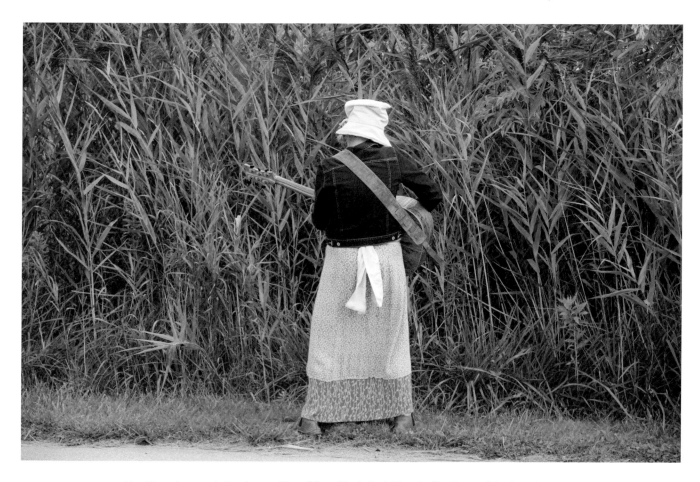

Mae Moore tunes up before her rendition of Gene MacLellan's "Snowbird" at Summerfolk, Owen Sound, ON

30

QIKIQTARUK (HERSCHEL ISLAND), YK

A cog from the whaling station community house. Herschel Island lies five kilometres off the coast of the Yukon in the Beaufort Sea. Constructed in 1893, the house is the Yukon's oldest frame building and is still in excellent condition.

COURTESY OF: Doug Olynyk, Yukon Heritage Resource Unit

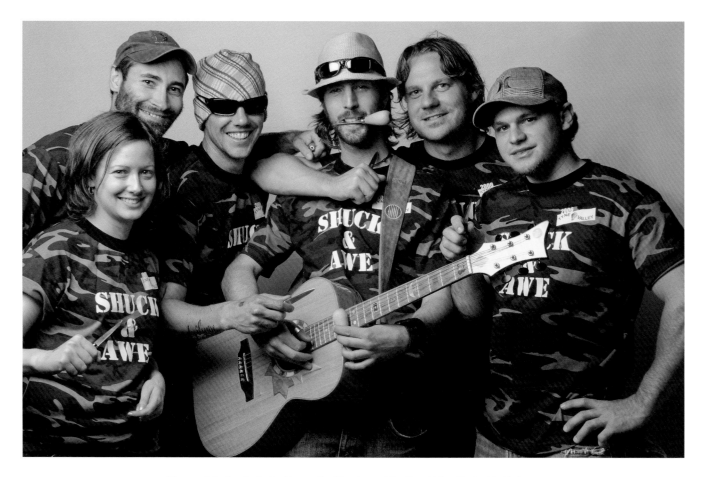

The 2006 Rodney's Oyster House shucking team at the Tyne Valley Oyster Festival, PEI

31

SIDNEY, BC

Door moulding from a DHC-2 Beaver bush plane. The first flight of a de Havilland Beaver was by flying ace Russ Bannock on August 16, 1947. The plane was built to work in the conditions of the Canadian North, with short take-off and landing capability and a flexible design to accommodate wheels, floats or skis as landing gear. Production ceased in 1967, after 1,657 aircraft had been built, but the original designs have been revived by Viking Air of Sidney, B.C., for a new generation of Beaver bush planes. COURTESY OF: David Curtis, Viking Air Ltd.

rewarding beyond measure to see my own learning about different characters and events from Canadian history magnified in the work of students at schools across the country—to see, for example, a bristol board project from a grade eight student in Brampton, Ontario, about Joe Labobe and the tradition of the Tyne Valley Oyster Shucking Championship in Prince Edward Island.

It may seem a bit ironic that this guitar-centric project comes from someone who is not a guitar player, but it is perhaps equally ironic that this is arguably Canada's most ambitious photography project from someone who is not a photographer. Well before the nuts and bolts of the project were in place, I knew I wanted a photographic documentation of the materials, construction, performance and public dissemination of the guitar. Sandor Fizli is a photographer from Halifax, Nova Scotia, who did a wonderful shot of George Rizsanyi for an October 2003 profile in the *Globe and Mail*. I hired Sandor to document each piece of material as it came in to George's workshop and to cover the construction process as well. Meanwhile, my old friend Doug Nicholson and I had talked for years—without actually articulating it, somehow—about having him work on the project. Inspired partly by the aesthetic of Apple Computer's ad campaigns, I decided I wanted to capture the encounters of people with the guitar in a

32

WOLFE ISLAND, ON
Don Cherry is the outspoken, occasionally outrageous and outlandishly dressed hockey commentator and former coach and player best known for his flamboyant jackets and mile-high collars. This material is from a pair of his trousers dating back to 1979. COURTESY OF: Don Cherry, with help from Cindy Cherry

NEWFOUNDLAND AND LABRADOR

Dave Myrick is the unofficial family historian for the Myricks, who have tended the lighthouse at Cape Race, Newfoundland, since 1874. Dave also maintains the famous Marconi station adjacent to the tower, where he runs the ham radio club. I was introduced to Dave by Sam Whiffen at the Department of Fisheries and Oceans, the agency responsible for the lighthouse.

Dave and I arranged a visit to the lighthouse on March 12, 2006, but Sam warned me that there might be problems accessing the site if the weather didn't co-operate. It had been a snowy winter, but a big melt was on. If there was enough snow, we could reach the lighthouse by snowmobile. If there was only a partial snow cover, a regular vehicle wouldn't be able to handle the mucky gravel road and I'd be left with helicopter as the only option—an option I certainly couldn't afford.

We picked up Dave on our way down to Trepassey, the village closest to the lighthouse and the home of the current keeper, Noel Myrick, and his son Sean. Noel was home sick and another shift was manning the lamp, but he advised Dave as to what piece we should take.

The weather wasn't too bad but the road conditions were not good. Dave called in a favour from a few guys in the village who gave up their Sunday to run us down to the lighthouse on their ATVs.

So there we were: Dave on the back of one machine, my cameraman, Geoff Siskind, on another and me on the third, bundled against the bitter cold, hugging the barest trace of a road along the undulating coast. To our left, an almost lunar plateau of rock, ice and scrub. To our right, a roiling cold green sea, spectacular cliffs and valleys, huge floating clouds of seabirds.

At the end of the ride, we were at this extraordinary outpost thirty metres above the steely Atlantic. A place that was a part of Canada long before Newfoundland signed on. We took the cabinet door from the motor inside the tower just under the lamp. Then we climbed farther up inside the lamp to do an interview with Dave right next to the massive bulb while the huge, hyper-radiant Fresnel lens swirled around us. It was like going from the roller coaster to the Tilt-a-Whirl at the edge of the world.

33

CAPE RACE, NL
Wood from the cabinet housing the twelve-horsepower motor that drives the revolving lamp at the historic lighthouse built in 1907. The Marconi wireless station there was one of two land-based locations to first receive the distress signals from the RMS *Titanic* on April 14, 1912. COURTESY OF: David & Noel Myrick, with help from Sam Whiffen at the Department of Fisheries and Oceans

Dave Myrick with the Myrick contribution
from the lighthouse at Cape Race, NL

 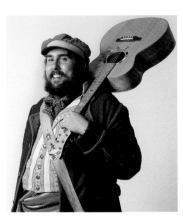 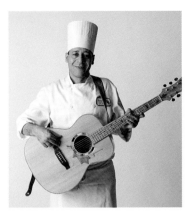 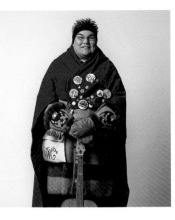

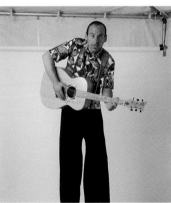 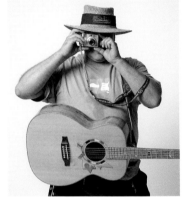 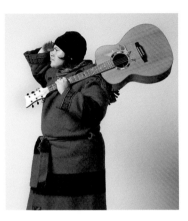 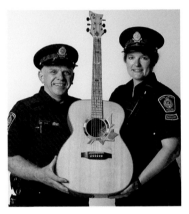

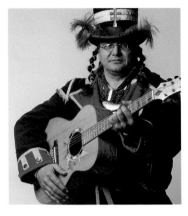 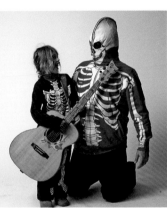 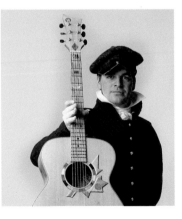 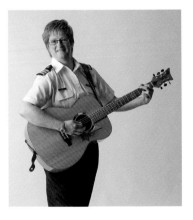

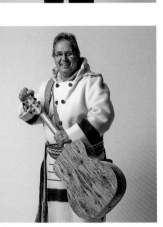 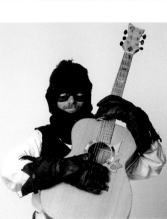 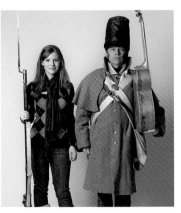

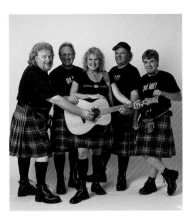
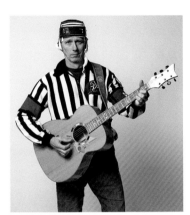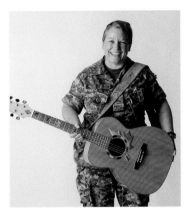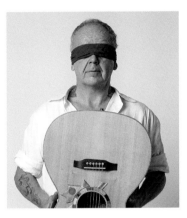
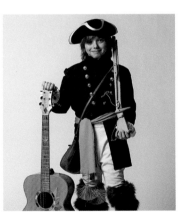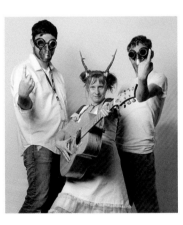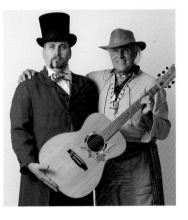
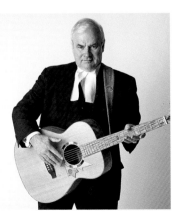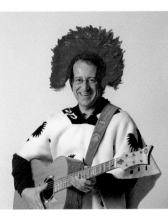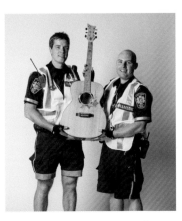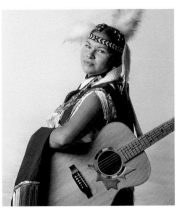

pure, white space. The idea was to strip away any notion of location and focus strictly on the commonality of all these various Canadians holding this very Canadian guitar—to minimize any signal noise of scenery or circumstance that might emphasize differences of region or language or culture or status. Doug devised a simple and portable studio that we could set up anywhere and get similar results.

The portraits you see in this book were taken in hotel ballrooms, school cafeterias, hockey rinks, curling centres, conference rooms, museums, nightclubs, churches, galleries, parking lots, theatres, garages, an officers' club, the top floor of the Royal Bank headquarters, the South Block of Parliament and countless festival tents. While these photos achieved the focus I was looking for, they also achieved so much more. There in these little white spaces across the country, people stepped up alone or in pairs or families or teams or clusters of friends and had their personal moments with this collage of Canadian history.

I wanted people to see a piece of themselves in the guitar—but what if they didn't? What if they decided it didn't belong to them, or they didn't belong to the idea it represents? But there it is over and over and over again. Hockey moms and bankers, infants and seniors, soldiers and punks,

34 OTTAWA, ON
Wood from a sideboard in the office of Canada's first prime minister, Sir John A. Macdonald. The furniture was ultimately moved to the East Block on Parliament Hill, where it now resides in the office of Senator Consiglio Di Nino. COURTESY OF: Gerald Keddy (M.P.) and Senator Consiglio Di Nino

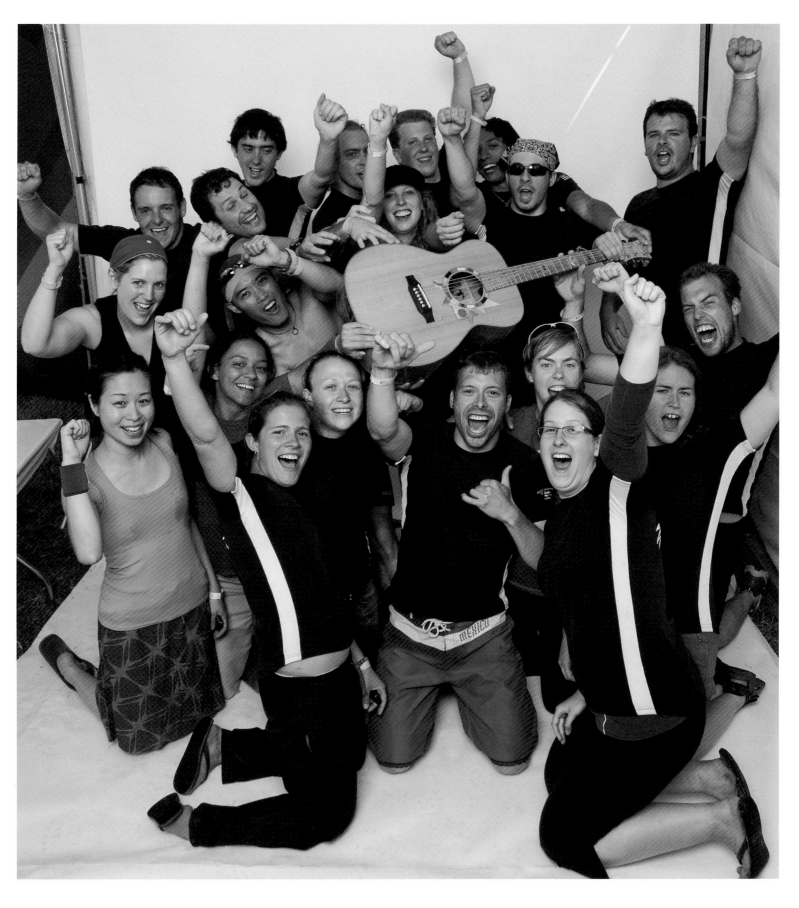

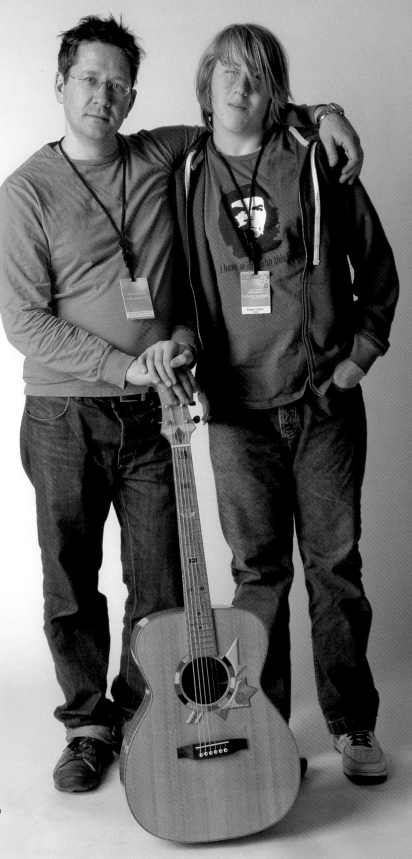

Photographer Doug Nicholson
with his son Gabriel

DOUG NICHOLSON (portrait photographer)

I wish I could remember the exact day that Jowi told me about his plans to assemble pieces of wood from across Canada and have them made into a national guitar. I know it was shortly after he met George, not that far from where I was living at the time. As he breathlessly spilled out the list of things that would draw people to this instrument, I told him I wanted to be the photographer for the project. Originally it seemed that I would be following the collection of the materials and the construction of the guitar, and then the performances on the final instrument as a kind of on-set photographer. By the time the guitar was to be launched, my task had transformed to what it is today.

When talking with Jowi, I knew it made sense to have as plain a background as possible but was a bit hesitant to use a plain white background since it might be too suggestive of Richard Avedon's portraits from *In The American West*. The background had to have as little detail as possible, though, since we wanted the photos to be stripped of local detail and carried by the subjects. The white backdrop just made sense. So often in Canada the landscape becomes a character itself, but for these photos I wanted the subjects to stand alone with the guitar and tell their story without intrusion.

I have taken tens of thousands of portraits of people with the guitar and almost as many photos of the guitar onstage, backstage, in airports and wherever people have gathered to see it, touch it, talk about and with it. People's reactions run the gamut from devotion to disbelief, and there is often a sense that they yearn to connect with the guitar and what they see it standing for. My time with the people who come to be photographed is often limited, and many of them are not used to being photographed. I have to work quickly to draw something out of them that will make an interesting photo and get a piece of them into the story of the guitar. Often I don't realize what I have until I finally get a chance to look at the photos, sometimes days later.

35

HAND HILLS LAKE, AB
Flooring from the community dance hall at the Hand Hills Lake Stampede. Started as a Red Cross fundraising event in 1917 by Jack "J.J." Miller, it is Alberta's longest continually running annual rodeo.
COURTESY OF: Blake Morton

 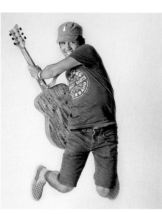 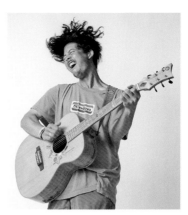 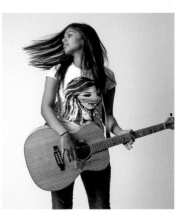

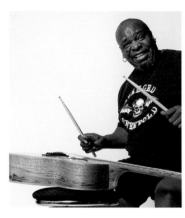 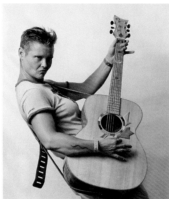 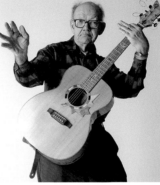 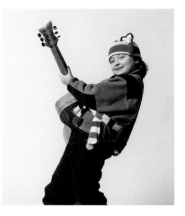

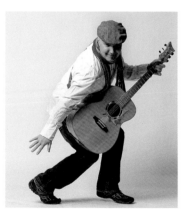 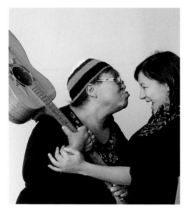 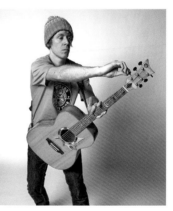 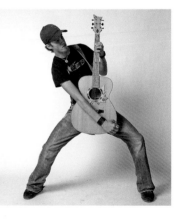

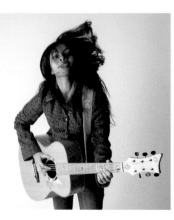 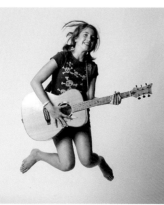 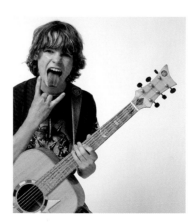 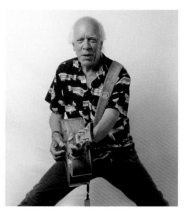

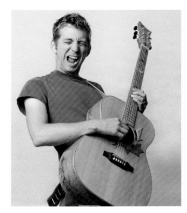 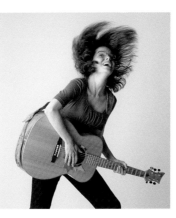 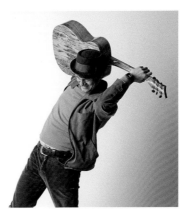 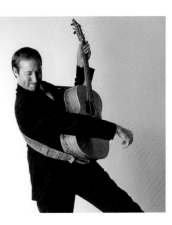

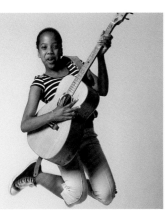 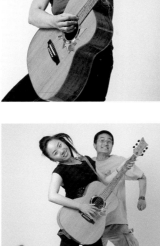 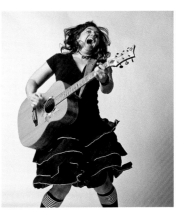

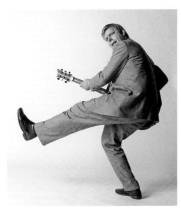 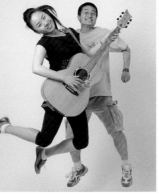 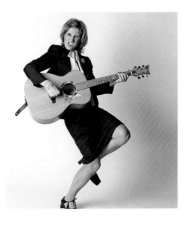 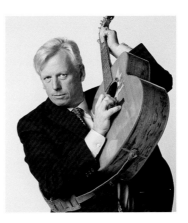

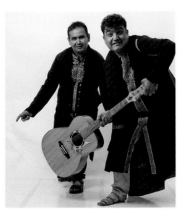 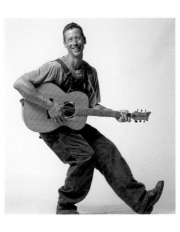 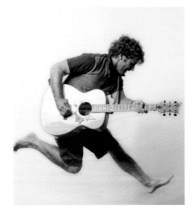 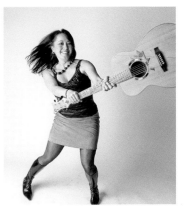

NORTHWEST TERRITORIES

One of the pieces my friend Bert Cervo connected us to was the Acasta gneiss discovered in 1989 about 350 kilometres north of Yellowknife. Radiometric dating of the rock's zircon crystals put the age at between 3.06 and 4.03 billion years old. This was good enough for scientists to declare it the world's oldest rock and for local politicos to have it mounted into the territory's Legislative Sceptre. So, naturally, it belonged in the guitar as well.

However, shortly after the launch of the guitar, I got an e-mail from Labrador basically saying: "Ahem, a rock in Labrador has been dated at 4.09 billion years old." Then, on September 25, 2008, came news of a rock from Inukjuak, on the eastern shore of Hudson Bay, dated at 4.28 billion years old. And just in case you were glad that at least all the contenders were Canadian, there's a challenger from the Jack Hills meta-conglomerate of Western Australia! It turns out there's some fancy geological semantics (geomantics?) around the dating of rocks and minerals, and the margin of error is something like a million years. So until this is settled by arm-wrestling geologists, I'm content to say that the first fret of Voyageur includes a piece of really, really, really old rock from the NWT that is also found in the official sceptre.

In a follow-up to this story, I was catching up on e-mail at the Vancouver Airport in August 2008 when I got a message from a guy absolutely enraged that we had used an inch-and-a-half-square piece of this rock. It was people like me, he said, who were denuding the forests. Now, I've had a few people reprimand me saying that Pierre Trudeau's paddle or Louis Riel's school should be in a museum. True enough, I suppose—much of Pierre's canoe stuff *is* at the Canoe Museum in Peterborough, Ontario, and the Convent of the Grey Nuns where Riel went to school *is* now the St. Boniface Museum—but I see the guitar as a kind of living, breathing museum. And I'm not sure exactly how much of this world's-oldest-rock (or second- or third-oldest) is left, but big parts of the planet are made of the stuff. I mean, it's not like I commissioned a guitar made from spotted owls or something.

36

GREAT BEAR LAKE, NWT
Acasta gneiss, disputably the oldest known rock in the world, estimated at 4.03 billion years of age. It is also part of the territorial sceptre of the NWT Legislature. COURTESY OF: Peter Skinner, with help from Bert Cervo

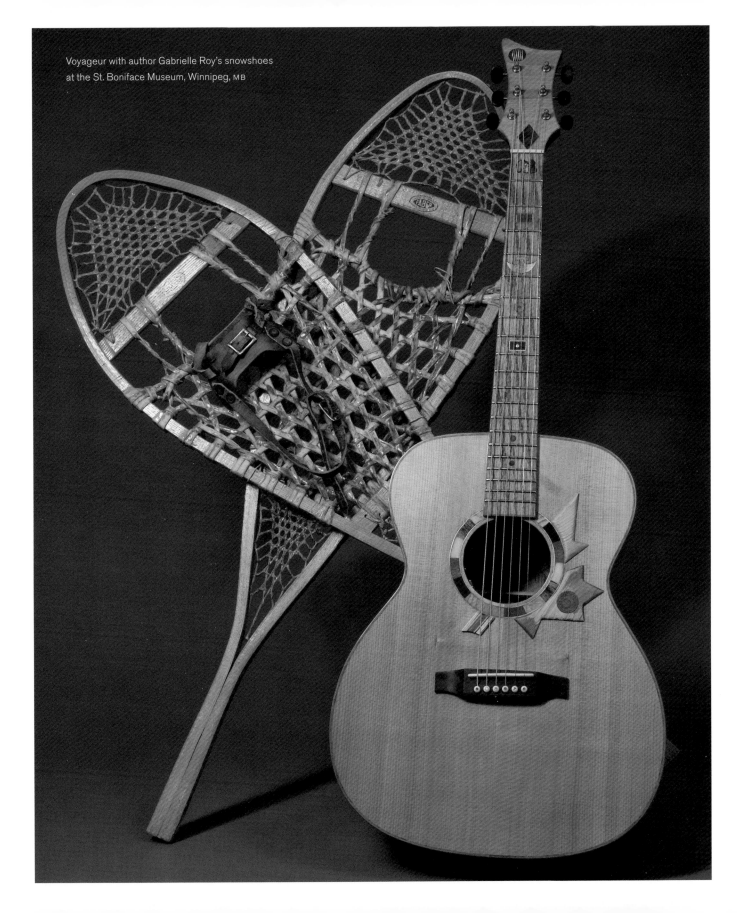

Voyageur with author Gabrielle Roy's snowshoes
at the St. Boniface Museum, Winnipeg, MB

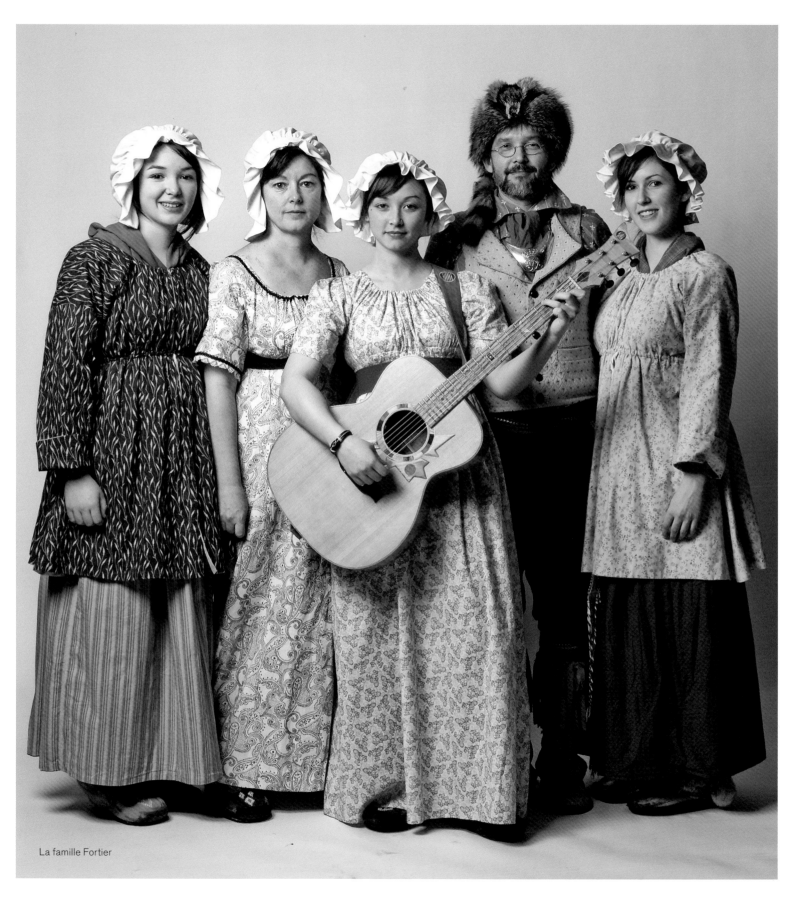

La famille Fortier

Muslims and Jews—Canadians of all backgrounds against that white backdrop in North West River, Labrador; Tlell, B.C.; Calgary, Alberta; Sudbury, Ontario; Rustico, PEI; Mont Tremblant, Quebec; Verigin, Saskatchewan; Iqaluit, Nunavut; St. Boniface, Manitoba; Lunenburg, Nova Scotia; Dawson City, Yukon; Caraquet, New Brunswick—revealing some essential part of themselves to Doug's camera, becoming the true stars of the shot, while the guitar in their hands becomes the character actor in the supporting role.

We've taken tens of thousands of these portraits and distributed them electronically, for free. By posting photos on their websites, blogs, Facebook and MySpace pages, or printing them out and hanging them in homes and offices, thousands of people have claimed their place in the Six String Nation and enfolded the guitar into their own story. I never tire of looking at all these beautiful, generous, Canadian faces. Each one lends specificity to something that could easily have been an abstraction.

37

KLEINBURG, ON
Born in Whitehorse, Yukon, Pierre Berton was to become one of Canada's most beloved writers, journalists and television personalities. He was the author of fifty books, most on various aspects of Canadian history. He is also remembered as a panellist on the CBC Television game show *Front Page Challenge* and for a famous cameo on the *Rick Mercer Report* just one month before his death in November 2004, at the age of 84. This is one of the bow ties he wore as his sartorial trademark. COURTESY OF: Peggy-Ann and Patsy Berton, with help from Rico Gerussi

NOVA SCOTIA

George Rizsanyi sometimes takes a select group of students into his workshop to teach them about the craft of luthiery. One of those students was Vice Admiral Duncan "Dusty" Miller. He commanded Canada's Naval Task Group in the 1990–91 Gulf War, headed Canada's East Coast Navy for three years and as his last job served as Chief of Staff for the Supreme Allied Commander's NATO Headquarters in Norfolk, Virginia. But here he was, having retired in 2003, sitting at a workbench in Pinehurst learning how to make guitars.

Now, for a guy like that you know retirement isn't all woodworking and card games. Among other things, he's a Research Fellow in Foreign Policy studies at Dalhousie University and sits on the board of directors of Pier 21. George introduced us by e-mail, and "Dusty" and I ended up having several long phone conversations about the project (and about his latest experiences in the local amateur theatre group—I'm telling you, the guy never stops). He agreed to join my list of honorary patrons and help move the project along however he could.

Using his connections on the Pier 21 board and with friends like Senator Wilfred Moore—at that time heading up the *Bluenose II* Preservation Trust—he helped connect us to the pieces from Pier 21 and *Bluenose II*. Apart from the great material support, he helped solve a credibility problem. Up until that point, when I told people I wanted pieces of Canadian history to make a guitar out of, they tended to look at me a little funny. Once we had the pieces of the *Bluenose II* and Pier 21, people were a lot more receptive to the idea.

Having Pierre Trudeau's canoe paddle early on didn't hurt, either. And when George and I went on Brent Bambury's CBC radio show, *Go*, on June 26, 2004, with guest appearances by Justin Trudeau and Senator Moore, it really helped pick up the pace of contributions. Lesson being: if you want people to take you seriously, nothing helps quite like having a friendly honorary patron with a chest full of medals and an awesome Rolodex.

MONTREAL, QC
A canoe paddle belonging to Canada's fifteenth and seventeenth prime minister (and a great outdoorsman), Pierre Elliott Trudeau. COURTESY OF: Justin Trudeau

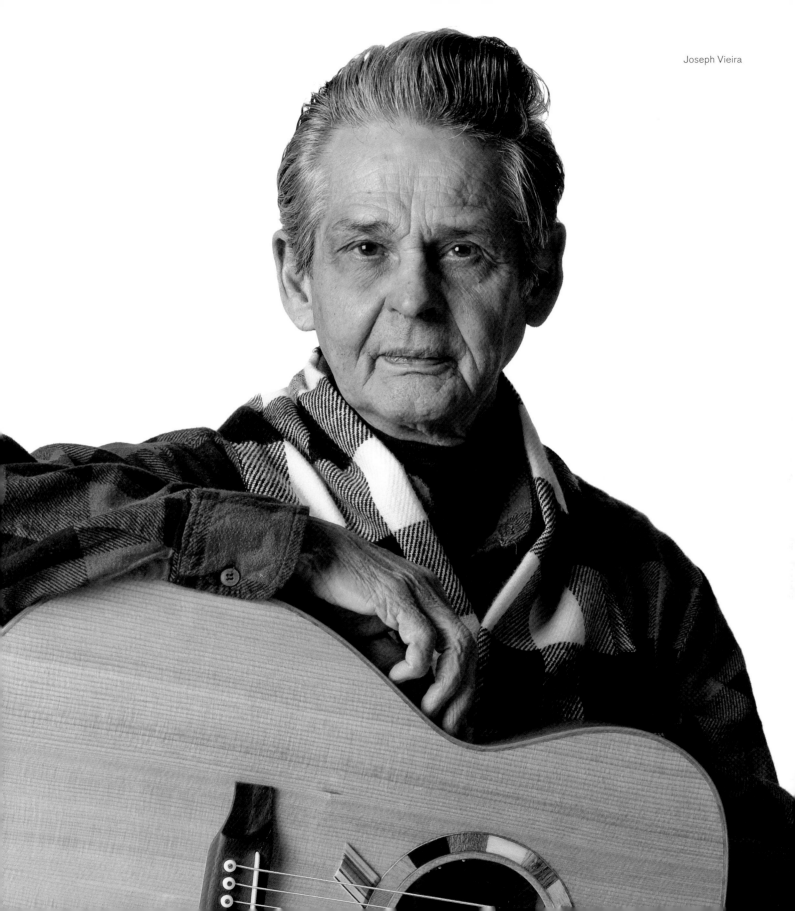
Joseph Vieira

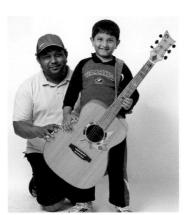
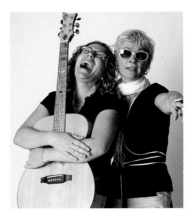

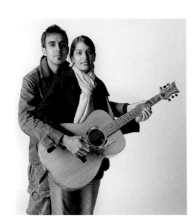
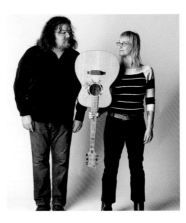
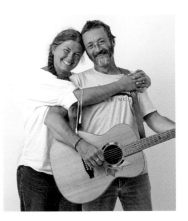
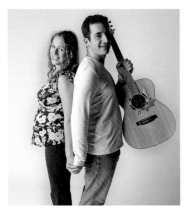
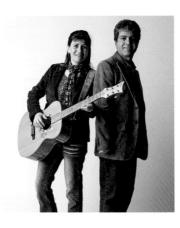

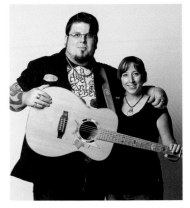
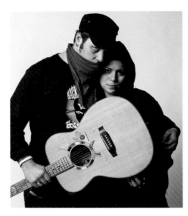
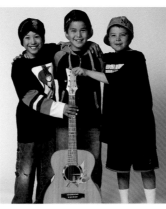

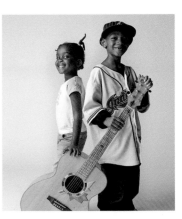

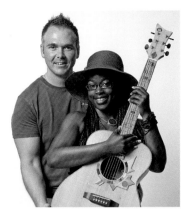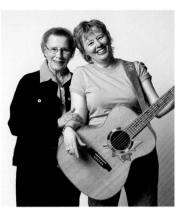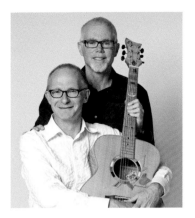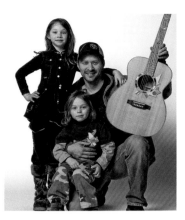
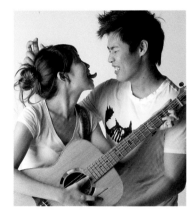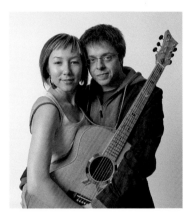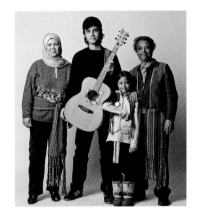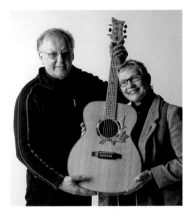
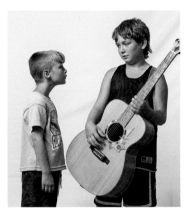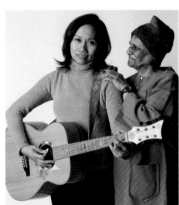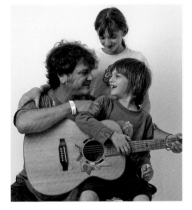
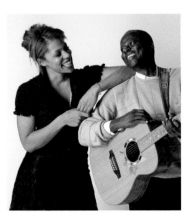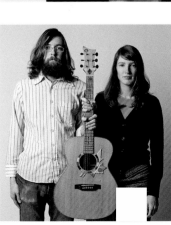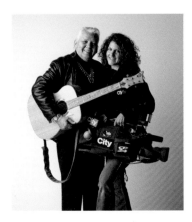

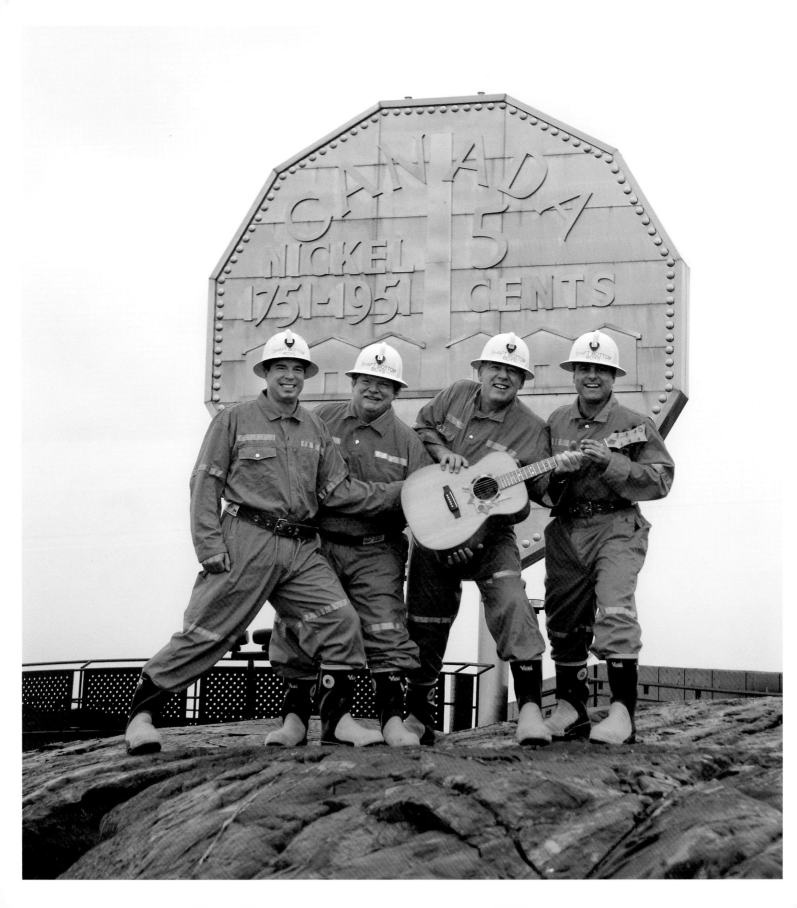

E A D G B E

BEYOND UNITY

SINCE THE WINTER OF 1949, B.B. King has named various of his signature guitars "Lucille." Willie Nelson's 1969 Martin guitar, which he still plays almost exclusively, is known as "Trigger." On Valentine's Day 2008, at the launch of the thirty-eighth annual Festival du Voyageur in Winnipeg—St. Boniface, the Six String Nation guitar officially received the nickname "Voyageur," the suggestion of Lieutenant Colonel Susan Beharriel of the Canadian Armed Forces, who attended the naming ceremony. We had begun canvassing for an official nickname on Canada Day 2006. It was one of the fields we asked people to fill in on the waiver form they signed to get their portraits taken. Among the suggestions: Woody, Woodsmoke, Canada, Kanata, Canuck, Kanuk, Anik, Loon, Beaver, Spirit, Harmony, Synergy, Identity and hundreds of others, from the silly to the solemn. One of the most popular suggestions was Unity.

< The Shaft Bottom Boys, a group comprised of Vale Inco workers, in front of the Big Nickel at the Dynamic Earth museum, Sudbury, ON

There was something hopeful and heartfelt about that suggestion. It spoke of a desire among Canadians in every part of the country to see themselves as one people. But "unity" is a loaded word in Canada, whether for Quebec nationalists, proud Newfoundlanders, disenfranchised First Nations, embattled immigrants or alienated Westerners. And the more places I've taken this guitar, the more I've realized I'm not really comfortable with the word either.

When all of this began in 1995, I think part of me was afraid that the idea of Canada was too fragile to withstand Quebec's challenge to unity, that our national symbology was too shallow and hackneyed to provide deep common touchstones, that our sense of our own history was too scattered and too equivocal to act as an anchor in a constitutional storm, that maybe we didn't have any unity to begin with. The more the project grew in concept, the more I hoped it would fill those gaps with an idea that incorporated the local and the national, the privileged and the populist, the past and the present, the pragmatic and the poetic, the textbook of history and the text message of popular culture.

As I've travelled across the country putting Voyageur into the hands of citizens of all kinds, I've discovered that the guitar merely provides a focal point for something that already exists in just about everyone it meets.

39

SUDBURY, ON
Nickel ingots from Vale Inco. Blasting for construction of the Canadian Pacific Railway in 1883 revealed a rich source of nickel-copper ore, and Sudbury ultimately became one of the world's great sources of nickel. It is the site of the world's largest coin, a stainless steel replica of a 1951 Canadian nickel. COURTESY OF: Mia Boiridy and Jim Marchbank of Science North, with help from Dennis Landry and Mike Large

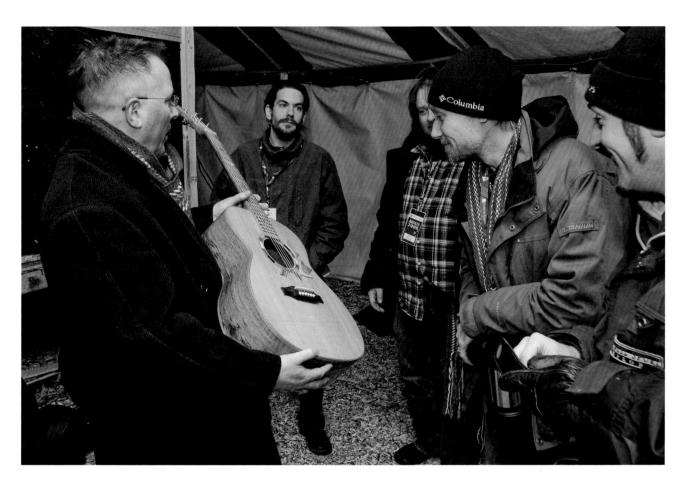

Gabriel Dubé and Pushing Daisies backstage at the 2008 Festival du Voyageur in St. Boniface, MB

40

WESTPHAL, NS
Wood from the Nova Scotia Home for Colored Children.
The orphanage was established in the early twentieth century
by James Robinson Johnston, Nova Scotia's first black
lawyer, who was murdered in 1915. COURTESY OF: Delvina Bernard

St. Boniface Museum director Philippe Mailhot and Lt. Col. Susan Beharriel unveil the guitar's official
nickname at a press conference launching the 2008 Festival du Voyageur at Fort Gibraltar, St. Boniface, MB

41

MONTREAL, QC
Piece from Seat 10, Row G, Section 321 of the old Montreal Forum.
It opened in 1924 as the home of the Montreal Maroons until their
demise in 1938. From 1926 to 1996 it was home to the Montreal
Canadiens. In all, it was home to twenty-six Stanley Cups: two for the
Maroons, twenty-four for the Habs. COURTESY OF: Bill Burke and Cathy Oliver

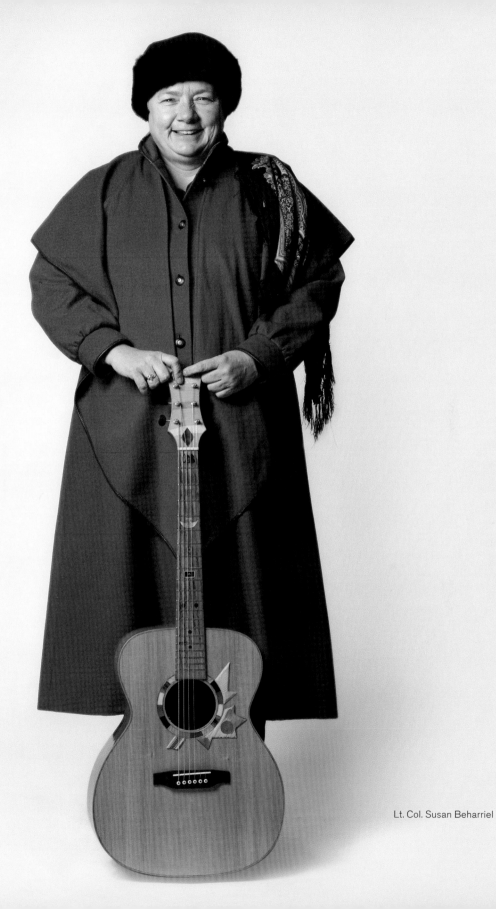

Lt. Col. Susan Beharriel

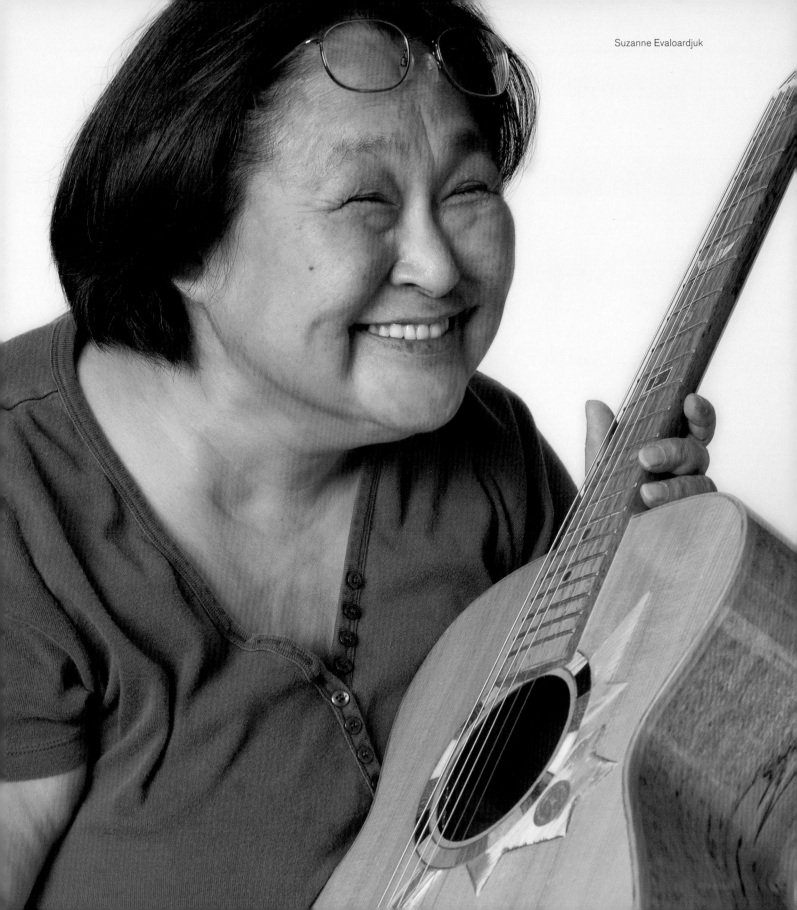

Suzanne Evaloardjuk

NUNAVUT

I want to tell you about one of my favourite people in the world: Bert Cervo. Bert is a German-Canadian who grew up in the Yukon. I first met him working on a CBC Radio special we were making in Berlin. Bert was the tech guy on our team. For him, nothing was impossible. With a pair of pliers and parts salvaged from an old Pong video game, he could build a radio station. He almost never stops laughing and he *loves* the Canadian north. On a frozen Yukon lake, he taught me how to sail a Ski-Doo off a snow ridge at high speed.

One of the great tragedies of Canadian geo-economics is that it costs exponentially more to fly to the North than it does to Florida or Frankfurt or farther. This place that occupies so much of our collective psyche, history, art and poetry is so little visited by most Canadians, myself included. So we had little sense of who to connect with or what we might want from the Far North to include in the guitar. Bert was our link. In Nunavut, he connected with artist, author and historian Suzanne Evaloardjuk, who sourced the whale baleen and muskox horn from Iqaluit and Cambridge Bay, respectively. He even made a little video documentary for us about Suzanne's contributions— all as a volunteer, in his spare time.

In June 2008, when we finally made it to the Alianait Festival in Iqaluit with the finished guitar, we set up our portrait studio at the local museum. It was a brilliant day with all kinds of folks from the community coming by to have their pictures taken. Among them were Suzanne and her husband, Patrick Nagle. We swapped stories about Bert (I think Suzanne might have referred to him as the Energizer Bunny) and got some wonderful portraits. The irony is that for all his contribution to the project in spirit and substance—and the fact that his enthusiasm for the North may infect others through this guitar—Bert himself has yet to have his portrait taken with Voyageur.

42

CAMBRIDGE BAY, NVT
Muskox horn. Muskox are more closely related to sheep and goats than to oxen. They are native to Arctic lands in Canada, Greenland and Alaska. They once veered to the edge of extinction, but have been revived thanks to conservation and reintroduction programs.
COURTESY OF: Suzanne Evaloardjuk, with help from Bert Cervo

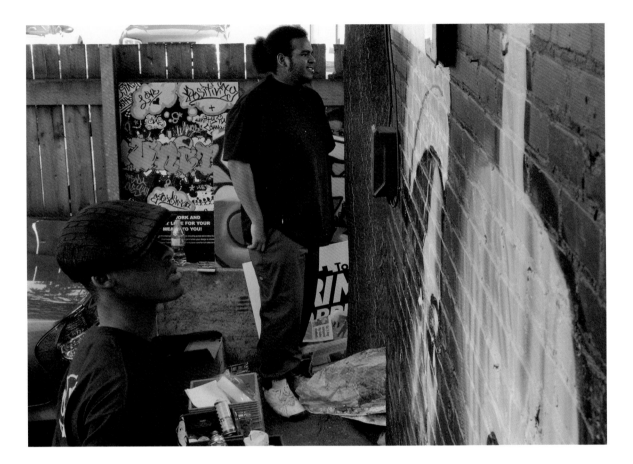

Jessey Pacho (Phade), left, and Kedre Browne (Bubblez), right, work on their
Six String Nation mural on the back wall of Lee's Palace on Bloor Street West, Toronto, ON

43

EDMONTON, AB
Insignia from the Princess Patricia's Canadian Light Infantry. Founded
with a gift from Captain Andrew Hamilton Gault in 1914, the regiment
is one of the most decorated in the Canadian Forces, having served in
Europe in both World Wars, in Korea, in the former Yugoslavia and
currently in Afghanistan. This piece is not actually in the guitar itself,
but on the strap. COURTESY OF: PPCLI, with special help from Lynn Bullock

I had imagined a silence in our sense of togetherness, but instead a vast vocabulary of national feeling spoke in a thousand different local accents. The fragment of Maurice "Rocket" Richard's ring on the ninth fret draws gasps in every part of the country. Tears well up over the story of the Golden Spruce of Haida Gwaii, even in places above the treeline. People who don't like oysters nonetheless beam at the mention of Joe Labobe's unbeatable shucking records. What people respond to is that sense of story, whether played out on grand stages or in quiet pockets of community. After all, what does any of us want from life? From among billions of people stretched over the vastness of time and space, most of us hope for nothing more than to say, simply, "I was here" and have it acknowledged. Our songs, our dances, our sport, our architecture, our gentlest poems and our bloodiest battles are all some variation on that humble theme of recognition. Street taggers and Conrad Black share this same impulse. If the quintessential Canadian complaint from any regional perspective is that the rest of the country doesn't really understand that perspective, then surely the first step is to make sure that everyone is heard and understood. Each piece of the Six String Nation guitar is part of a voice that speaks to that understanding. The pieces are not representative or emblematic. They simply open the door to one part of the story that waits to be told by the

44

FORT SMITH, NWT
Preserved well across a broad range of the Arctic, the tusks of the mammoth (*Mammuthus primigenius*), believed to be extinct for some ten thousand years, comprise the only source of consistently high-quality, easily carved ivory, such as this piece used by master carver and storyteller Sonny MacDonald.
COURTESY OF: Sonny MacDonald

KYRIE KRISTMANSON

I first encountered the Six String Nation guitar in Ottawa, at the 2006 Ontario Council of Folk Festivals. I was seventeen at the time and curious to learn more about the folk music scene. In the hotel lobby I wove through crowds of musicians, talent buyers, artistic directors and agents and paused near a group of people huddled around a guitar. I paced back and forth a few times hanging around to work up the nerve to ask for a turn. Not long after, the guitar was passed my way and I had the honour to meet Jowi Taylor and to try out the Six String Nation guitar for the first time.

Later, when I played the guitar in concert, I came to fully understand its significance. It was February and Jowi was in town for Winterlude, so I invited him to attend a gig I was playing at a local café. That night I played songs written about many parts of the country, all represented by the various artifacts built into the body of the instrument. As I played, a change occurred for me: no longer was the guitar wood, frets and steel strings, but it was something much more alive and fluid, like a poem. I thought that in the same way a poem juxtaposes disparate words to bring clarity to feelings and situations, the Six String Nation guitar places disparate objects side by side to bring clarity to this country, its history and what it is to live in it. I believe the Six String Nation guitar is the musical equivalent of the railway and the radio: it unifies a wide country in a joyful way to which both musicians and music-lovers alike can sing along.

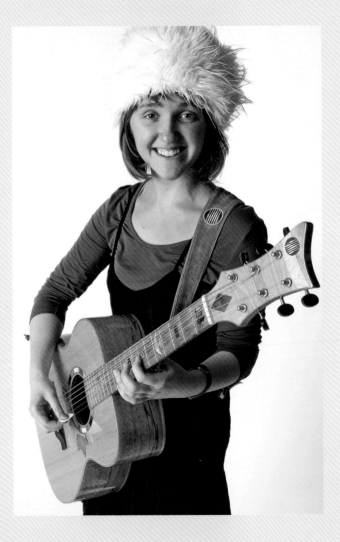

Six String Nation mural at Lee's Palace, Toronto, ON

45

RICHMOND, BC

Red cedar from Jack Uppal's mill. As a one-year-old, Jack arrived in Vancouver from India in 1926. Sikhs faced a great deal of discrimination in Canada (including the infamous Komagata Maru incident), but Jack was one of the first Sikhs to enter the Vancouver public school system. Like many Sikhs, he found work in the timber industry and soon became the first Sikh to own a timber mill, Goldwood Industries. COURTESY OF: Jack Uppal, with help from Ali Kazimi

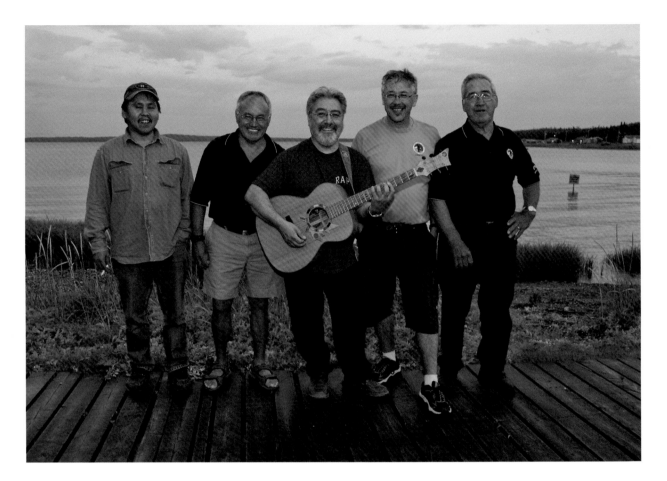

Famed Labrador group, The Flummies, at the 2008 North West River Beach Festival, NL

46

CAVENDISH, PEI

Wood from the house where *Green Gables* author Lucy Maud Montgomery lived with her grandparents, and from which they ran the local post office. There, Lucy would intercept the rejection notices from publishers for her manuscripts—until a positive response finally came from a Boston publishing house, and a legend was born. COURTESY OF: John and Jenny MacNeil

people who play the guitar, who sing along to it, or who share their family tale as they hold the guitar for their portrait session.

I'm glad someone suggested the name "Voyageur" for the guitar. Before the Province of Ontario made humble Highway 11 into a glittering cottagers' conduit to the Muskokas, our family used to cross the blacktop on our way up to Cobalt every summer for dinner at a long-gone stop called the Voyageur Restaurant. The food wasn't very Voyageur-esque—burgers and fries rather than pemmican—but the decor and menus and paper placemats were festooned with images of canoes and pelts and traders in buckskin jackets. The voyageurs were the original Canadian cultural mosaic—French, Metis, Native and English—and we felt a kinship with them as we finished our milkshakes and continued north beyond cottage country. While the word "Voyageur" literally means "traveller," our history has infused it with a sense of adventure and purpose. It's the difference between "journey" and "trip." "Voyageur" also implies a connection to the wild Canadian landscape, which even for a dedicated urbanite like myself seems to resonate in our collective imagination. "Voyager" (without the "u") is also the name of one of two satellites that are now the most distant human-made objects in space. Well, this guitar explores the outer reaches of Canadian identity as musicians use it to play every kind of music under the stars.

47

HARTLAND, NB
Piece from the world's longest covered bridge, which crosses the St. John River from Hartland to Somerville and measures 390 metres long. It was built uncovered in 1901 and covered during repairs in 1922. A side walkway was added in 1945. COURTESY OF: the town of Hartland

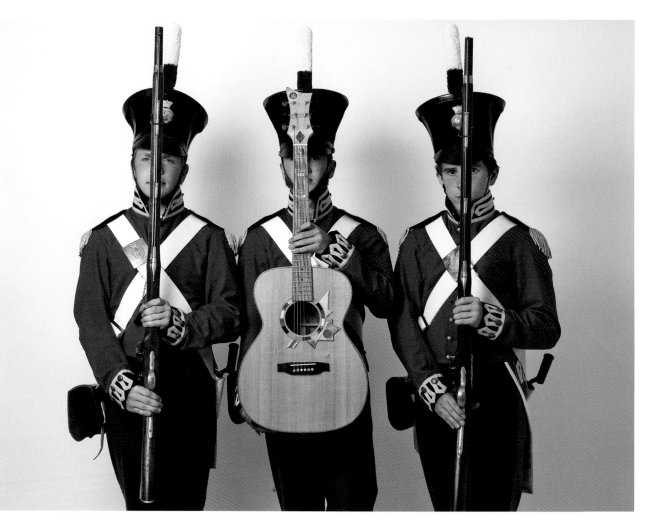

Left to right: Ben Martin, Justin Chartrand and Peter McNichol as members of the "Royal Sappers and Miners," Rideau Canal builders, Ottawa Dragon Boat Race Festival, June 2007

48

TORONTO, ON

Window frame from painter Lawren Harris's studio at 25 Severn Street. Unlike most of his Group of Seven compatriots, Harris came from money. He commissioned the studio in 1914 from American architect Eden Smith. It served as studio and living space for J.E.H. MacDonald, A.Y. Jackson, Frederick Varley and Tom Thomson. Other artists, such as Emily Carr and Harold Town, also held temporary residencies there. Artist Gordon MacNamara bought the building from Harris in 1948 and bequeathed it to his adopted son, photographic artist James Mathias. COURTESY OF: James Mathias

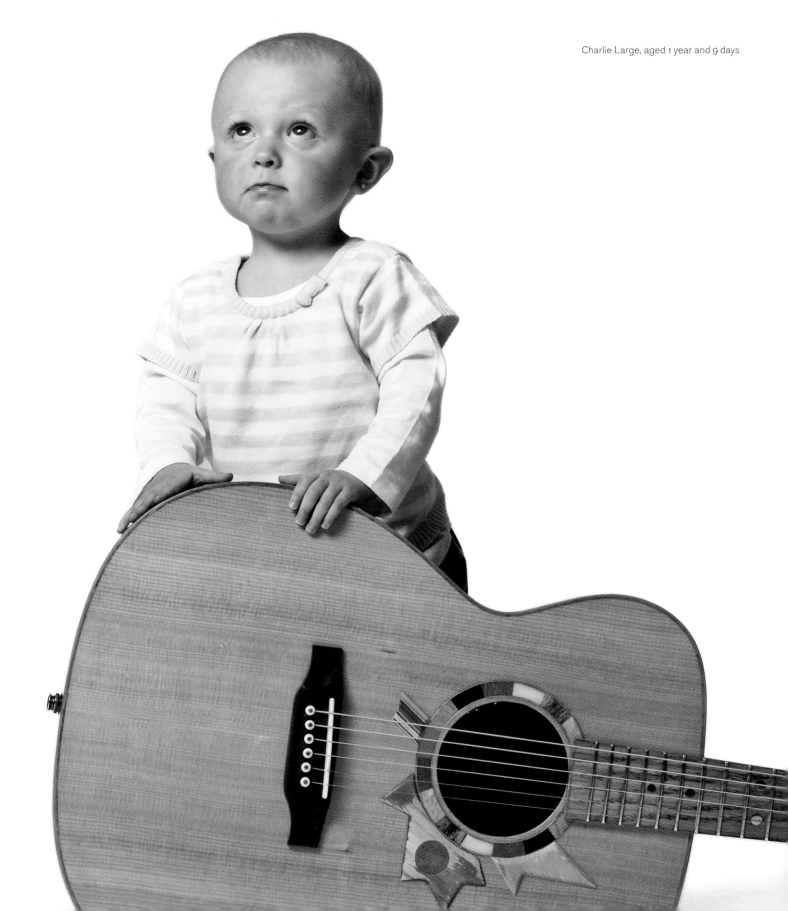

Charlie Large, aged 1 year and 9 days

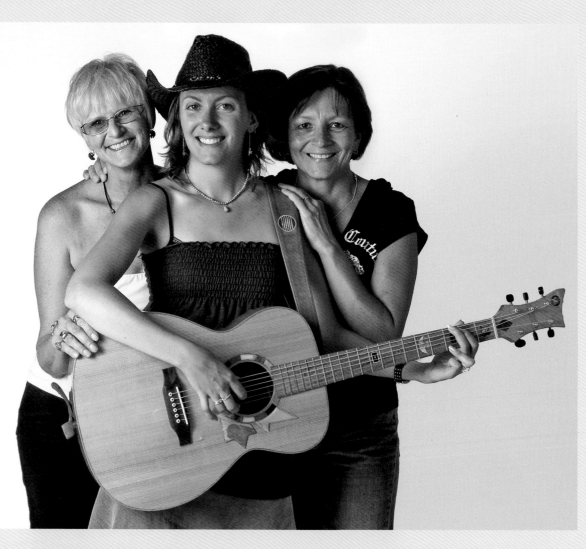

Tour manager Amanda VanDenBrock and her two moms, Deborah Hill (left) and Deborah Grencher (right)

49

YELLOWKNIFE, NWT

Wall piece from the Wildcat Cafe, the oldest original building in Yellowknife (1937). It has been through several incarnations but still operates as a restaurant today. A replica is also found at the Museum of Civilization in Hull, Quebec.

COURTESY OF: the Wildcat Cafe and Peter Skinner, with help from Bert Cervo

AMANDA VANDENBROCK

The pride that I feel in the heritage and beauty that is contained in the Six String Nation guitar brings tears to my eyes every time I think about it. My first encounter with Voyageur and Jowi Taylor was at the Hillside Festival in Guelph, Ontario, in 2006. I was amazed at the idea, and its majesty haunted me. Jowi was also very open and forthcoming with his time and thoughts, and I think we spoke for well over an hour. When the possibility of working with the guitar was presented to me, I excitedly met with Jowi again. Even though it was sort of a "job interview," I sat down and told him first thing how the piece moved me and I started to cry. The best part was, Jowi cried with me. I knew that I had made a friend for life.

During my travels with Voyageur I met so many fantastic and interesting people—normal, everyday folk who would curiously wander up to our booth and ask what we were all about. I would then take people on a "tour" of the guitar. I would start with the "superstar" pieces to get them interested: Paul Henderson and Wayne Gretzky's hockey sticks, Pierre Trudeau's canoe paddle, Nancy Greene's ski.

People would get hooked and then I would point out the local pieces—John Ware's cabin while in Calgary, or the piece from Massey Hall while in Toronto. But the true magic would come from mentioning pieces such as the *Christmas Seal* floating X-ray clinic while in St. John's, Newfoundland, and people would say "I was on that boat!" Or while talking with a man at the Calgary Folk Festival whose grandparents were Doukhobors from Saskatchewan, and he remembered visiting them and seeing the grain elevators. Seeing the look on the faces of folks such as these, when they realized their own history was included next to Rocket Richard's Stanley Cup ring, was unbelievable. Most would get quite choked up. There were many tears.

It was the biggest honour I have had so far in my life to be able to travel with Voyageur along with Jowi and Doug. This one object has made me feel more national pride than any other person or event ever will. With more tears in my eyes, I say thank you, Jowi, for bringing us this wonderful gift and taking me along for part of the ride.

50

DAWSON CITY, YK
Piece from the *Yukon Rose*, a storied supply vessel instrumental in building the Alaska Highway, the land route that ultimately killed the riverboat trade.
COURTESY OF: Marc Johnston

Janelle Wookey and Cecile St. Amant

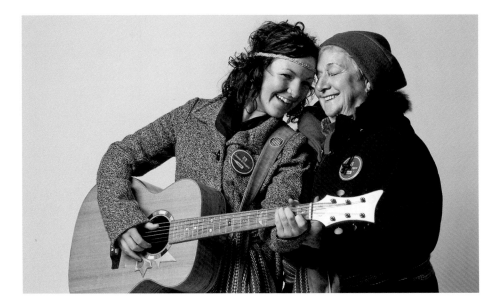

That's what I've come to hope that the guitar will ultimately mean to people: a probe, a data-gatherer about what it is to be Canadian. Unity is a lovely idea, but there's something too pat, too smug, too final, too earnest about it. I've realized Unity isn't the thing to fight for or to prop up. Listening. Understanding. Respect. These are the goals worth pursuing. With luck, Unity will be their by-product.

GIMLI, MB
"Lucky stones," a natural formation found on the shores of Lake Winnipeg and popular with Gimli's Icelandic community, the largest Icelandic population outside of Iceland. COURTESY OF: David Arnason, with help from Katrina Anderson

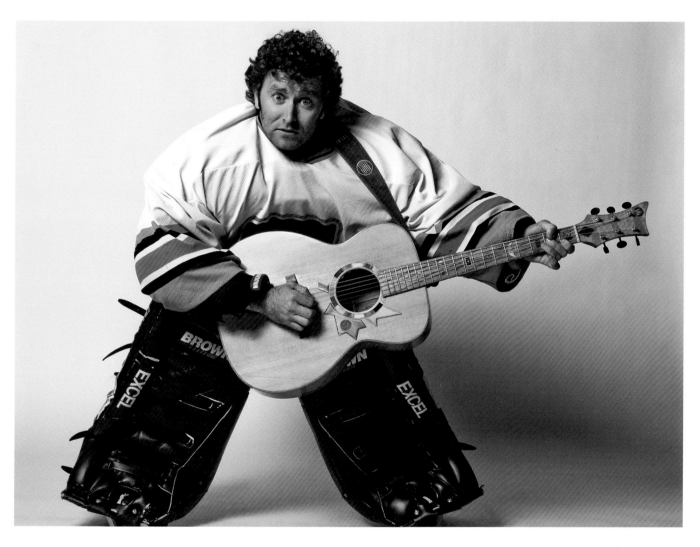

Grant Lawrence

52

TORONTO, ON

The top of one of the hockey sticks used by Paul Henderson during the 1972 Canada-Russia Summit Series, perhaps the defining moment in Canada's relationship with its "national game." Henderson scored the winning goal of the series at 19:26 of the third period in the eighth and final game on September 28th, 1972. COURTESY OF: Paul Henderson, with help from Marvin Goldblatt

ONTARIO

I knew I somehow wanted to represent the huge Finnish community of Northwestern Ontario, so I called my friend Cynthia Kinnunen and asked her what was the most quint-essentially Finnish place in Thunder Bay. Without a pause, she simply said, "The Hoito." Ask anyone from Thunder Bay and they'll say the same thing. It was established in 1918 in the basement of the Finnish Labour Temple at 314 Bay Street, and has been serving up Finnish pancakes, clab-bered milk and *mojakka* ever since. Finnish pancakes aren't like other pancakes. They're thinner but about three times as dense. We ate way too many of them on our visit. But the Hoito isn't just famous because of the food. It's famous because it was the centre of union activity for the nearby logging camps. The restaurant still runs as a workers' co-operative, just as it did in 1918, so it's part of Canada's labour history as well.

Cynthia gave me the name of the main guy at the Hoito: Arno. Just Arno. His full name is Arno Perna, but it took a while to get that from him. He really is just known as Arno. I called up Arno and I said, "Hi Arno, I'm doing this project to build a guitar from historical materials from across the country and we've got Pierre Trudeau's canoe paddle and the *Bluenose II* and I know your restaurant is an important place in the Finnish community and I really want something from Thunder Bay so I'm wondering if you've got anything made of wood you'd like to contribute to the project?" There was a long silence at the other end of the phone and he finally replied, "I'm sorry. There's noth-ing historical here." It was the old Canadian saw: if it's from here, it can't be very important. It took me three or four attempts—with Catharine Saxberg and others adding to the pressure—before Arno finally accepted that maybe it was the whole place itself that was historic. He contributed one of the giant soup paddles used to stir the *karjalanpaisti*, *hernekeitto* and *mojakka*—not to mention the Finnish soul in all of us.

53

THUNDER BAY, ON
Soup paddle from the Hoito Restaurant, Canada's longest continuously run restaurant and an important anchor in the area's Finnish community. The restaurant has been run as a co-operative since its founding in 1918.
COURTESY OF: Arno Perna and the staff of the Hoito, with thanks to Cynthia Kinnunen

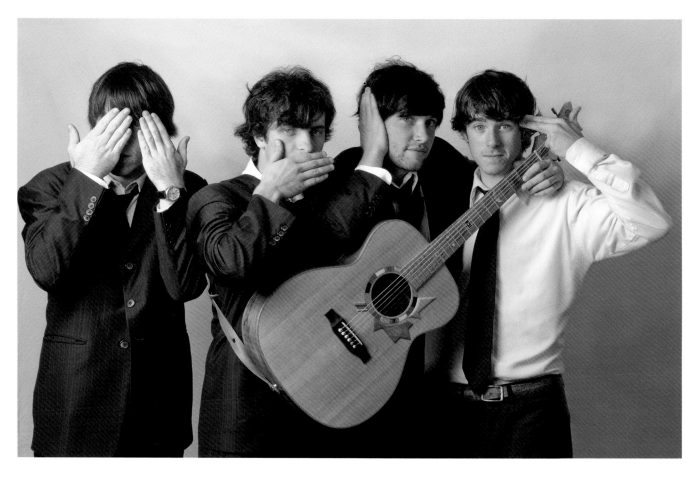

The Chucky Danger Band from PEI

54

OTTAWA, ON

Oak door frame from the Centre Block on Parliament Hill. Ottawa was selected by Queen Victoria as the capital city of the Province of Canada in 1857. The Parliament Buildings were completed by 1876 but destroyed by fire in 1916. The new Parliament Buildings were completed in 1927. This piece is taken from near the Prime Minister's office. The main entrance to the Centre Block is depicted on the obverse of the Canadian twenty-dollar bill. COURTESY OF: Public Works and Government Services Canada, with special thanks to Brian Cooke

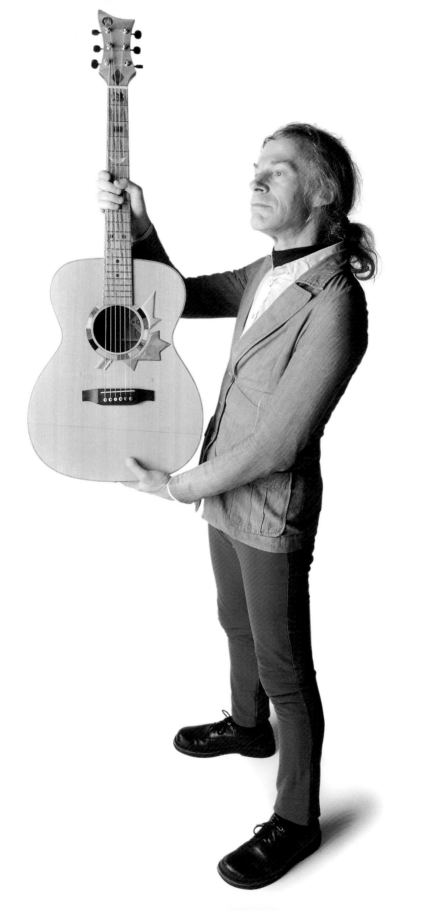

Allen Vatcher

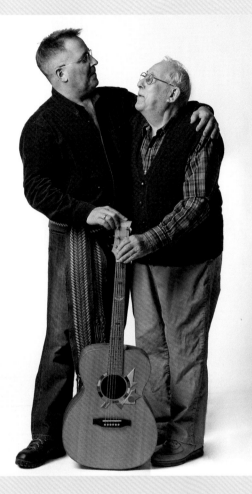

GABRIEL DUBÉ (Francophone liaison)

Lorsque mon collègue et ami Jowi m'a fait part des projets de la guitare "Voyageur" et de la Nation Six Cordes à la fin des années 1990, j'ai tout de suite saisi leur énorme potentiel.

Mais ce n'est qu'à l'occasion de la présentation officielle de la guitare à Ottawa, le 1er juillet 2006, que j'ai été témoin des réactions de nos concitoyens, des réactions qui m'ont donné des frissons et m'ont parfois ému jusqu'aux larmes.

Depuis, "Voyageur" poursuit son voyage à l'échelle du pays, tandis que cet instrument unique au monde parle littéralement aux Canadiens de toutes les générations et de toutes les origines, qui n'ont aucun mal à s'identifier aux différents éléments qui composent la guitare et qui, par le fait même, définissent notre pays.

Je suis fier de faire partie de ce projet et je remercie Jowi de m'avoir accordé ce privilège.

< Gabriel Dubé with his uncle Georges Boisjoli

55

QUEBEC CITY, QC
Theatre drapery pin from Théâtre Capitole. Designed by American architect Walter S. Painter in the beaux arts style, the theatre is at the heart of the only urban district in North America designated as a UNESCO World Heritage Site.
COURTESY OF: Jean Pilotte and Sylvie Jacques

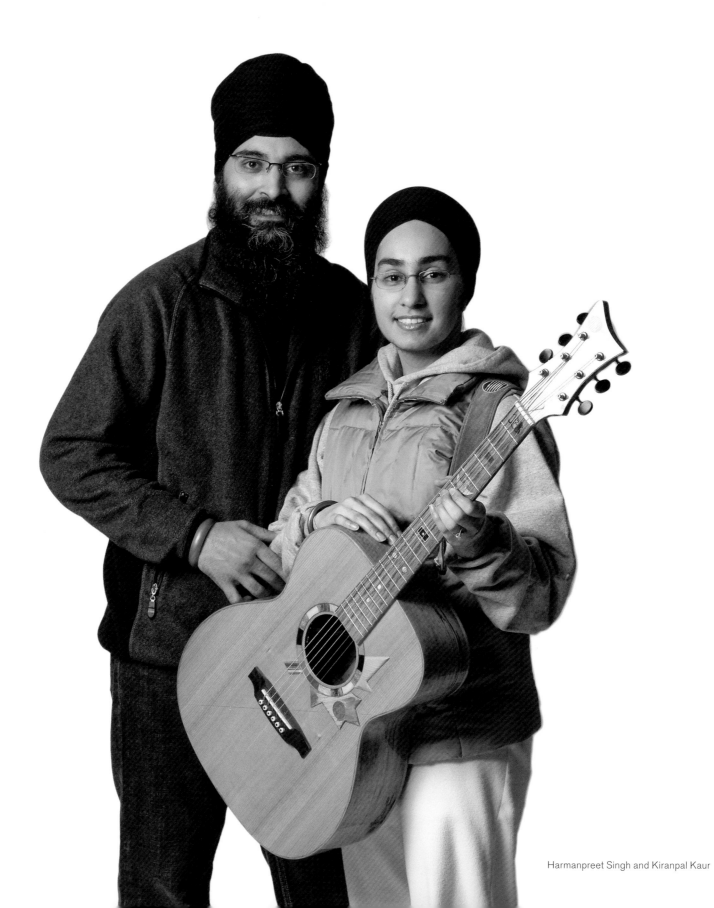

Harmanpreet Singh and Kiranpal Kaur

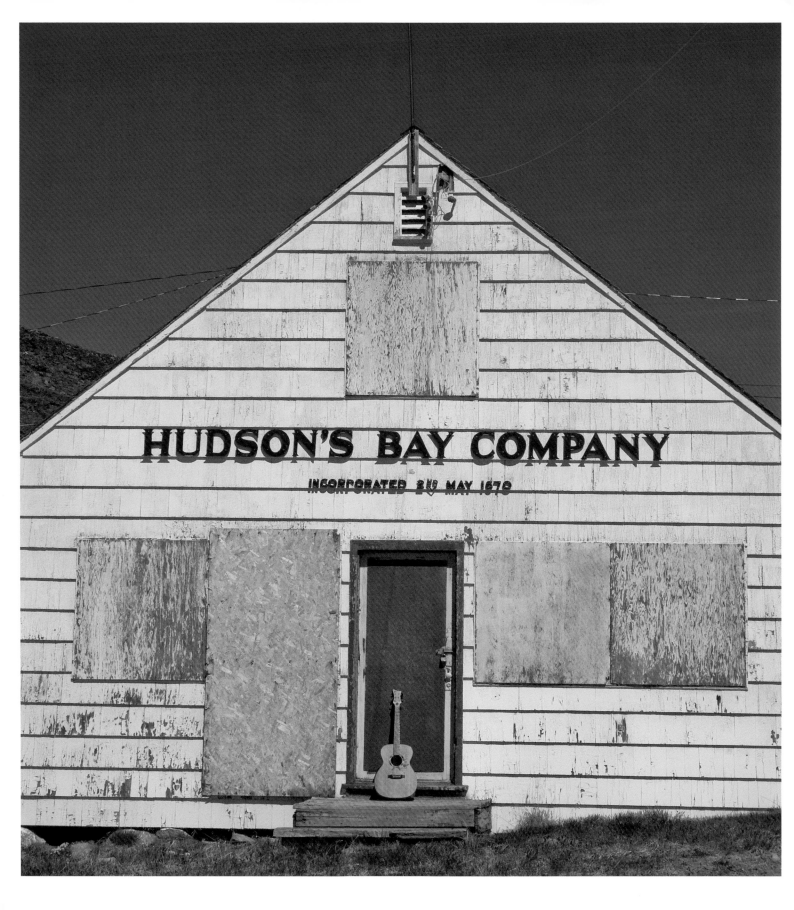

E A D G B E

BON VOYAGE

IT'S AWKWARD, INVITING MUSICIANS TO play a guitar other than their own. They don't know the instrument. They're not sure of its tone, its character, its playability. George Rizsanyi's guitars have a good reputation, but not every musician knows what to expect when Voyageur is thrust into their hands—especially when they learn that the guitar is made from hockey sticks and canoe paddles and grain elevators and kitchen tools and baseboards and boats and antlers. On top of that, the musician may already be a committed Martin or Gibson or Larrivée or Taylor or Manzer player, and may even have an endorsement deal with one company or another. These are all reasonable causes for a musician to hesitate about playing Voyageur. But almost none do. Most are curious how this collection of odds and ends is going to sound, and also what it will feel like to hold all this history in their hands. Each time a musician plays Voyageur, I feel deeply honoured by their leap of faith. And yet, I couldn't tell you the

< Original Hudson's Bay Company building in Iqaluit, NVT

PRINCE EDWARD ISLAND

When I think of PEI, I think of the same four things I'll bet most people do: Stompin' Tom, Confederation, Anne of Green Gables and oysters. I'm sure that must drive you nuts if you live there, but I had to start somewhere. For the oyster story, I started at Rodney's Oyster House in Toronto. Rodney Clark is widely regarded as Canada's Oyster King and he hails originally from PEI. I went to the restaurant to talk to Rodney, expecting him to help me source some mother-of-pearl for inlay work. But, without a second thought, Rodney told me I had to get something from Joe Labobe, a Mi'kmaq Indian who was the greatest oyster shucker in Canadian history and perennial winner at the famous Canadian Oyster Shucking Championships in Tyne Valley, PEI. Joe had passed away, but Rodney gave me a few contacts. A few months, e-mails and phone calls later, I found myself sitting in Genevieve Labobe's living room on the Lennox Island Reserve near Tyne Valley with son Leslie and daughter Mary and their spouses, my cameraman Geoff, and songwriter Lennie Gallant, who came along for the ride (travelling around PEI with Lennie is a bit like travelling around England with one of the Royal Family). Genevieve presented us with Joe's championship shucking knife, one he'd modified himself to give it a narrower blade. George took a chunk from the wooden handle, which is now the seat for the strap post on the bottom of the guitar.

Several months later, after the guitar was born, we returned to Tyne Valley for the Oyster Festival, where the shucking championships take place at the arena. We reunited with the whole extended Labobe clan, including grandkids and cousins and great-grandkids. At our information and portrait booth we got the usual amount of folks marvelling at Maurice's ring and Pierre's paddle. But, over and over again, folks who came up to see the guitar almost immediately asked, "Where's Joe's knife?" That's when I knew it meant as much to the community as it meant to us to be there for that occasion.

If you're ever in PEI around the end of July or beginning of August, you should really make a point of going to the Oyster Festival—even if you're one of those nutbars who doesn't like oysters.

56

LENNOX ISLAND FIRST NATION, PEI
Handle from the championship shucking knife of local Mi'kmaq hero and perennial Canadian oyster-shucking champion (who also came in second at the international championships in Galway, Ireland), the late Joe Labobe. COURTESY OF: the Labobe family, with thanks also to Rodney Clark

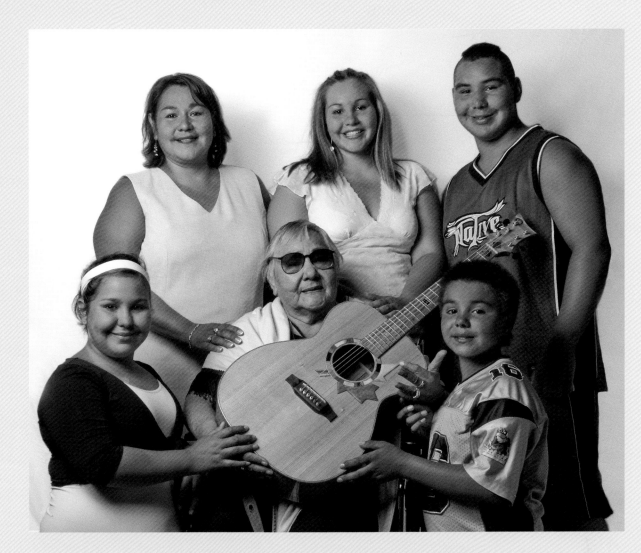

Joe's widow, Genevieve Labobe, and just a few family members

PIC RIVER FIRST NATION, ON
Moose antler, a popular material for carving among the Ojibway people.
Pic River sits at an important junction for travellers and traders on Lake
Superior. From 1821 to 1888, it was the site of a Hudson's Bay trading post.
COURTESY OF: Eva Couchie, with help from Sid Bobb

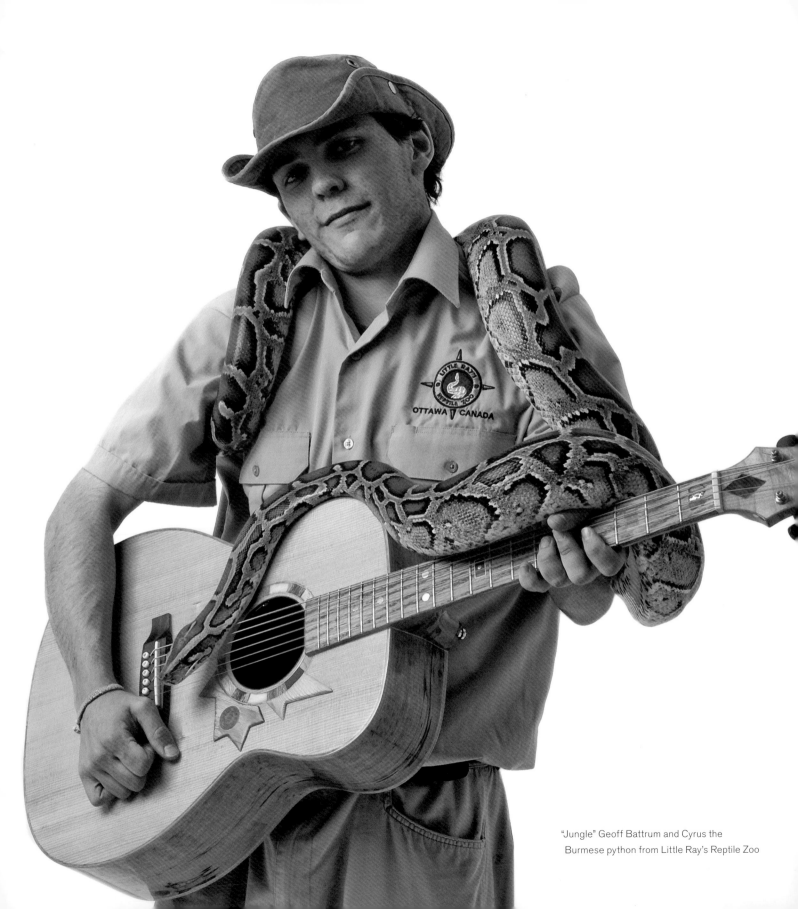

"Jungle" Geoff Battrum and Cyrus the
Burmese python from Little Ray's Reptile Zoo

number of times the musician turns to me or to the audience and says that the honour is theirs. That breaks my heart in the best possible way.

But there's another challenge in putting Voyageur into a musician's hands—or, for that matter, into anyone's hands. A guitar is a fairly familiar object, and chances are that most people have held one—or at least pretended to hold one in their bathroom-mirror air guitar performances. Most guitars don't come laden with the kind of meaning that accompanies something as simple as a ring or a photograph. Voyageur is different. Its elements are part of our history, and some of them are deeply personal for the people who contributed them. To hold this guitar is to draw from and contribute to a kind of collective memory.

At our booth at festivals, curious people come up to see the guitar, read the display panels and take a brochure. Then we invite them to get their portrait taken with the guitar. As they step into that white space, the thing I hear over and over again is, "I didn't think I'd be allowed to touch it." This breaks my heart in another sweet way. I want everyone, even for just a moment, to feel that the guitar belongs to them, to recognize a part of themselves in it, to become part of the story and, in touching some part of the instrument meaningful to them, to leave an atom or two of themselves behind in the exchange.

58

NEAR DEASE LAKE, BC
Nephrite jade, the official gemstone of the province of British Columbia. It is especially prized in markets in China.
COURTESY OF: Kirk Makepeace, Jade West

QUEBEC

For all the cool stuff I collected for this project, I never could have dreamed I'd get a bit of gold from Maurice Richard's very own and very first Stanley Cup ring. The Rocket commissioned rings for the Canadiens after their 1956 Stanley Cup victory, which kicked off a five-year Cup dynasty. The Rocket himself had scored the winning goal.

The stars really had to align for this one. My friend Dave Treherne is that anomaly in Toronto, a full-on, taunting, gloating Habs fan. He was born in Montreal and saw his first game at the Forum when he was six. When the Richard family put Rocket-related memorabilia up for auction in 2001, Dave went to Montreal ready to spend. He bid eight thousand dollars for the ring. When I told him about the Six String Nation project, he made the mistake of mentioning the ring, then made a potentially tragic mistake: agreeing to let me take a tiny piece of it.

I asked a friend at the Harbourfront Centre Craft Studio in Toronto if she could recommend someone to perform the delicate surgery. She suggested metal studio resident Bebhinn Jennings. Dave and I met with Bebhinn, who acknowledged there was some risk of damaging the structural integrity of the ring but assured us the risk was manageable.

Things were very quiet, with lots of three-way gazing and long pauses. But Dave agreed to go ahead with the procedure. Just before handing the ring to Bebhinn, he turned to me and said: "You realize this is my daughter's college fund, right?" I choked out a yes and took Dave for a stiff drink next door while Bebhinn unsheathed her tools.

After a couple of drinks, Dave took off. "Return it when you've got everything you need," he said. I got back to the studio, and there was the ring, polished so smooth and bright you'd never know a piece was missing. Next to it, in a tiny zip-lock plastic bag, lay a little dot of gold.

For one reason or another, Dave and I weren't able to hook up for months. For what seemed an eternity, that blue ring box sat in my bathroom drawer among expiring aspirins and ointments. Every so often I'd open it to make sure the ring hadn't somehow disappeared. It was a relief the day Dave finally took it back.

59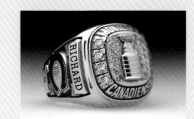

MONTREAL, QC
Maurice "Rocket" Richard's 1955–56 Stanley Cup ring, one of those commissioned by Richard for the team in place of the NHL's silver platters. COURTESY OF: David Treherne

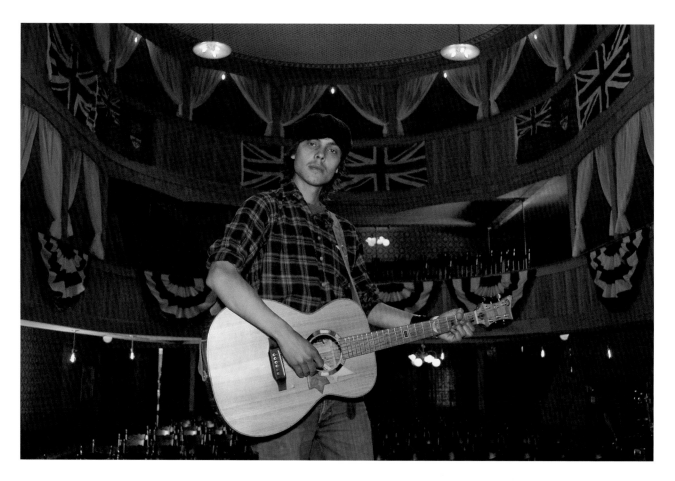

Johnny Rodgers onstage at the Palace Grand Theatre, Dawson City, YK

60

CHARLOTTETOWN, PEI

Wood from J.R.'s Bar. Johnnie Reid, the son of Lebanese immigrants, started J.R.'s as a lunch counter in 1967. Eventually it became a bar and an important stop for musicians on the Atlantic club circuit. Many greats played here, but it is most famous for performances by Anne Murray and Stompin' Tom Connors— as well as the first public performance of "Snowbird," by local songwriter Gene MacLellan. The building was torn down by the City of Charlottetown in 1999.

COURTESY OF: Johnnie Reid

One night at the venerable Ship Inn on Solomon's Lane in St. John's, I held a small fundraiser for the project. All kinds of musicians lent their time. Sandy Morris was one of them and he brought with him two very special guests: the singer Jenny Gear and Ann Brennan, widow of Dermot O'Reilly. Born in Dublin, Dermot became a pillar of the Newfoundland and Labrador folk music community over thirty-five years as a member of the group Ryan's Fancy. He passed away on February 17, 2007. Ann brought him along in the form of a photograph and a small box containing a handful of his ashes. Dermot, she told me, had always wanted to play the Six String Nation guitar, and this was the best she could do.

The final evening of the 2007 Newfoundland and Labrador Folk Festival included a tribute to Dermot O'Reilly featuring some of the island's best-loved musicians. They named the last session of the evening the Six String Nation Guitar Jam. For the final tune, Jean Hewson led the assembly in the "Ode to Newfoundland" using Voyageur. Written by Governor Sir Cavendish Boyle and composer Hubert Parry, the Ode was adopted as the national anthem of an independent Newfoundland in 1904 and was readopted in the 1980s as the provincial anthem (the only official provincial anthem in Canada). It is redolent with history and aspiration. And there on that stage in Bannerman Park, it was played on Voyageur. The

61

KAINA FIRST NATION, STANDOFF, AB
Ammolite carved in the shape of Blood Tribe Buffalo Skull symbol. Extremely rare, ammolite is found only in parts of Alberta and North Dakota. COURTESY OF: Rick Tailfeathers, Kaina First Nation

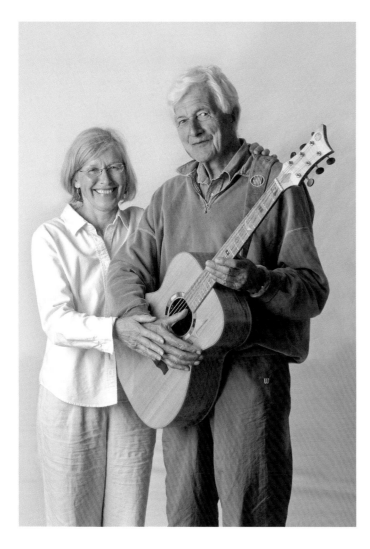

Tyler Aspin's mother and stepfather, Linda and John Aspin

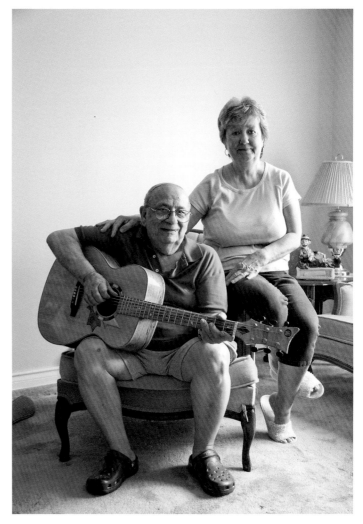

Johnnie and Judy Reid

62

ATHOLVILLE, NB

Piece from the French frigate *Machault*, scuttled in July 1760 in the Restigouche River during a battle with British ships near the end of the Seven Years War. Remnants were unearthed during excavation for a mill site in the 1970s. COURTESY OF: Allan Muzzerall

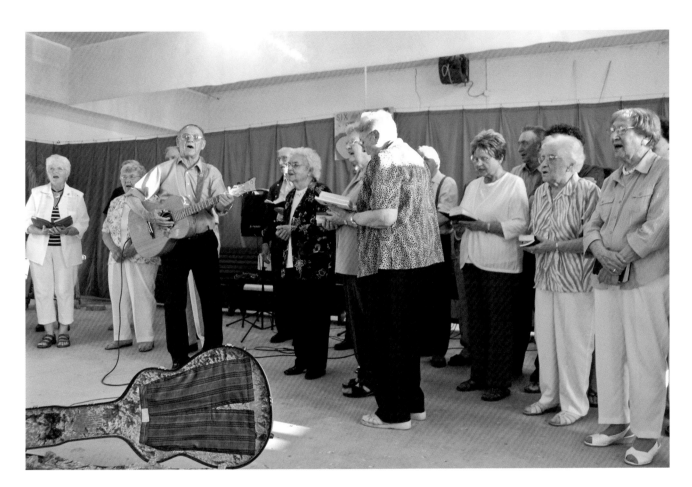

Saturday afternoon sing-a-long in Verigin, SK

63

OTTAWA, ON

Copper from the roof of the Library of Parliament. Opened in 1876, it is the only original building on Parliament Hill to survive the great fire of 1916. Recently refurbished (including a new copper roof), the Library is featured on the obverse of the ten-dollar bill. COURTESY OF: the Library of Parliament, with help from Susan Murray

LAURIE BROWN

Imagine all the energy generations of Canadians have raised in the quiet of bedrooms, with guitars on laps, trying to find the right words and chords to express what was in our hearts. The guitar has been our witness as we struggled to find our voice, individually and collectively. That voice has emerged, single, solitary and strong. It's the singer-songwriter with a guitar that best sums up our musical heritage. When Jowi spoke to me (many years ago now) about the Six String Nation guitar, I knew this would be the way to harness all that energy. You can feel it wherever the guitar goes; people lining up to touch it, play it, have their picture taken with it. This country is so spread out, with so many vast stretches of emptiness between us, that there are very few things that actually connect us. The CBC and the Canadian National Railway have been our tangible, real connectors. But I think it's the guitar that expresses who we really are, what we think and dream about in our little pockets of community dotted across the land. Now we have the Six String Nation guitar, a solid, ringing symbol of what really pulls at our heartstrings.

∧ Laurie Brown and her daughter Haddie

> Facing the corner baseboard in the parlour of the Manoir Papineau, Montebello, QC

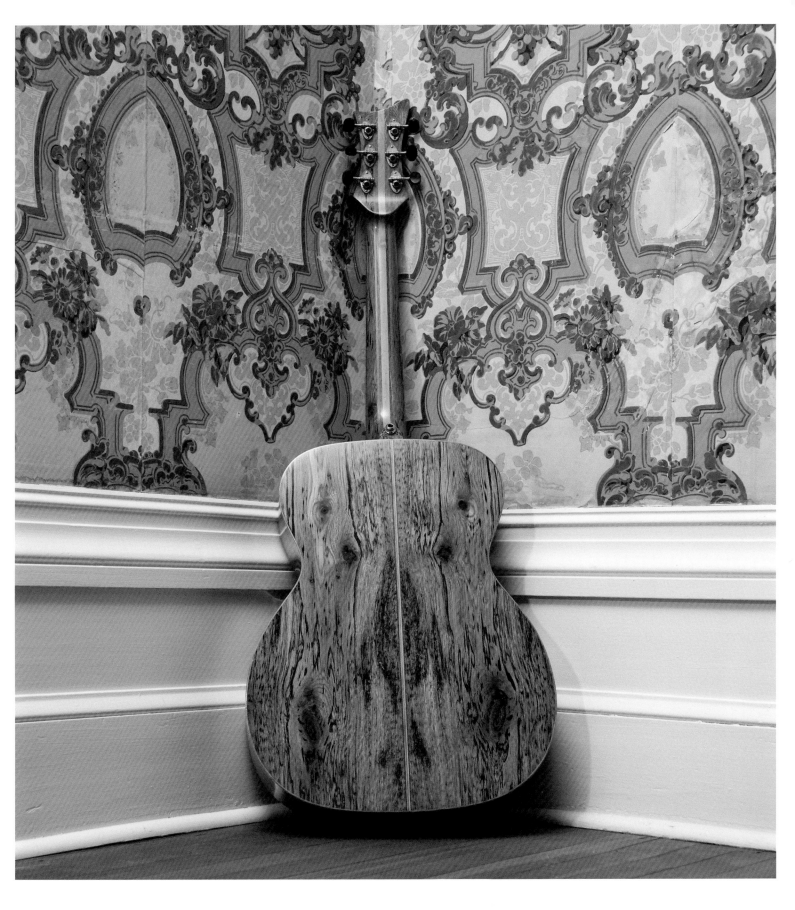

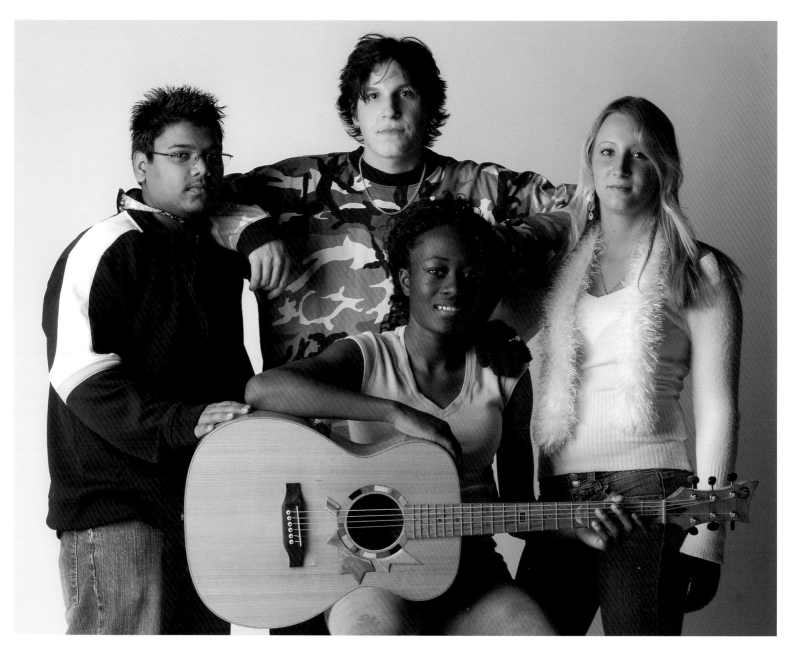

Clockwise from left: Ram Heera, Randy Mattix, Victoria Snow and Hannah Asare, students at North Peel Secondary School in Brampton, ON

emotion of that moment had me shaking. With the tribute to Dermot O'Reilly still fresh in everyone's ears, it was the perfect example of how this simple object could convey the multi-faceted spirit of people, places, emotions and ideas.

This guitar was not built by a corporation and it was not funded by the government. It is the product of the combined efforts of a dreamer, a craftsman and those mad enough to lend support. To hold it, play it, compose music on it, have a portrait taken with it—none of these actions implies endorsement of a product or a patriotic platitude. For the craftsman, it is meant to be capable of playing whatever music comes to it. For the dreamer, it is meant as a conduit for the expressions of those who encounter it.

One of those encounters inspired Doug Larson, a biologist at the University of Guelph, to build a guitar from pieces of the natural history of the Guelph area. The story of Voyageur inspired a hobbyist in Northern Ontario to propose an all-Franco-Ontarian guitar. And I've been inspired myself to plan other versions of the project: a guitar that tells the story of American music history, a guitar made from mementoes of men and women taken by AIDS in Africa and an oud co-designed and constructed by Israeli and Palestinian luthiers to be an instrument of peace in that part of the world.

For now, I'm content to share Voyageur with as many citizens of our Six String Nation as I can, hear more of their stories conducted through it and, if I can get the help to do so, take it to Canadians abroad. For the myriad ways this crazy project has been embraced, the honour has been mine.

SASKATCHEWAN

The grain elevators of the Canadian prairies are disappearing. New methods, new routes and new business models have rendered most of them obsolete. In their day, the elevators weren't just for storing the fruits of the harvest—they were social spaces. When people scattered over vast farmland need to gather for a celebration, where are they going to meet? At the tallest and most central point, of course! With these iconic structures, a way of life is vanishing.

I wanted to recognize the legacy of the elevators before it was too late. Cliff Arnal at the Ravenscrag Grain Elevator told me about the elevator at Verigin—not only a well-built structure, but one with a terrific story attached to it. The Russian Doukhobor community of Verigin (sometimes spelled Veregin) was established with a grant from author Leo Tolstoy and led by Peter Verigin after his release from exile in Obdorsk. The village was established in 1904 and the grain elevator was built four years later. Over the next three decades, splits within the Doukhobor leadership scattered large parts of the community to B.C. and Alberta. It's the modern era, though, that has done the most to dwindle the population. As small-scale farms give way to big agribusiness, and as young people choose life in Yorkton or Saskatoon or Regina or Calgary, the community gets smaller and more grey-haired.

With help from members of the community, we managed to get a piece of the elevator right around Verigin's ninety-eighth birthday. Doug Nicholson and I returned with Voyageur for the Doukhobor Heritage Festival on July 14, 2007. The hospitality was extraordinary. Keith Tarasoff treated us to Chinese food when we arrived. John Trofimenkoff, seventy-two years of age, insisted on sleeping on his couch so that Doug and I could each have a bed. The festival committee had special pins made to commemorate the visit of the guitar. All of which made it even more poignant that we photographed so few people under the age of fifty. Keith's fifteen-year-old granddaughter, Larissa, took part in the prayer meetings and wore traditional garb for a set of portraits, but the rest of the time she was plugged firmly into her iPod. We sensed that the elevator that is still the pride of the community might actually outlast the community.

64

VERIGIN, SK

Piece from a Doukhobor grain elevator. The Doukhobors were a Christian pacifist sect from Russia under the leadership of Peter V. Verigin. Persecution by Czar Nicholas led to the exodus of about 7,500 Doukhobors to Canada in 1899, with financial support from author Leo Tolstoy. The community ultimately split, with about six thousand relocating to British Columbia in 1907.

COURTESY OF: Philip Perepelkin and the Doukhobor community near Verigin

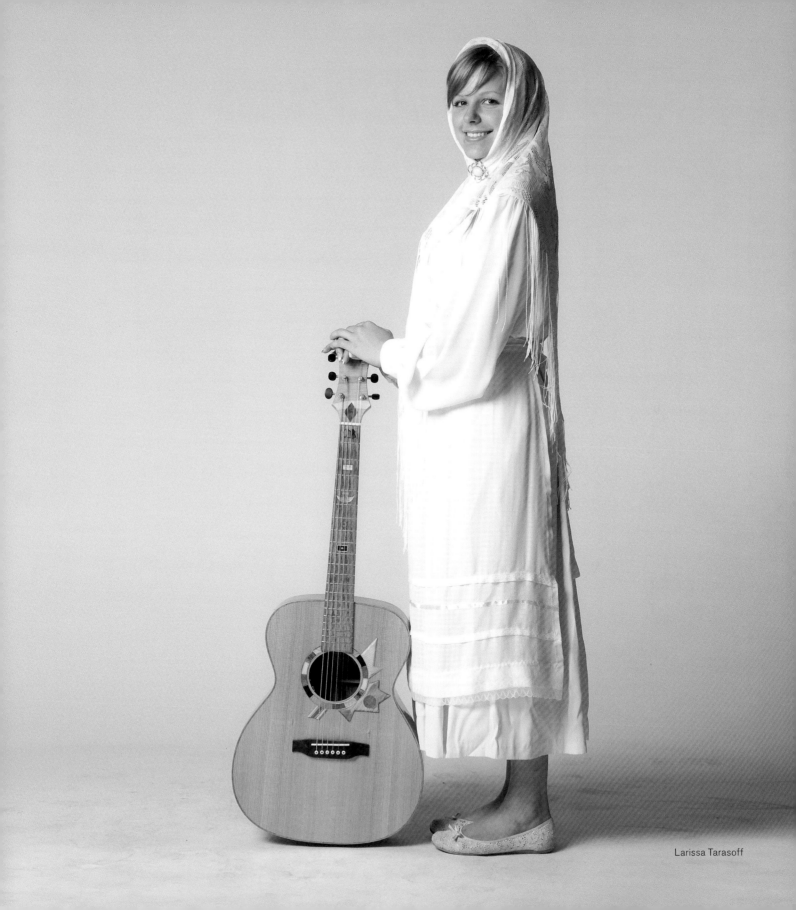

Larissa Tarasoff

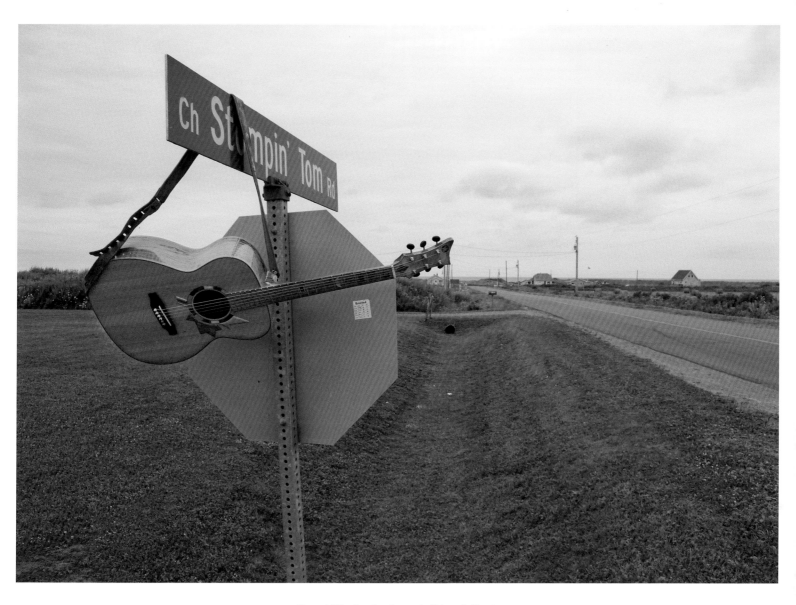

< Stompin' Tom's schoolhouse in Skinner's Pond, PEI

65

ALMONTE, ON

Part of the original home of basketball inventor James Naismith. Born in 1861, he was a star athlete at McGill University in Montreal before moving to the U.S. to teach. There, inspired by a childhood game called "Duck on a Rock," he introduced basketball on December 14, 1891. Twelve of his original thirteen rules are still in use today. COURTESY OF: Rick Edwards

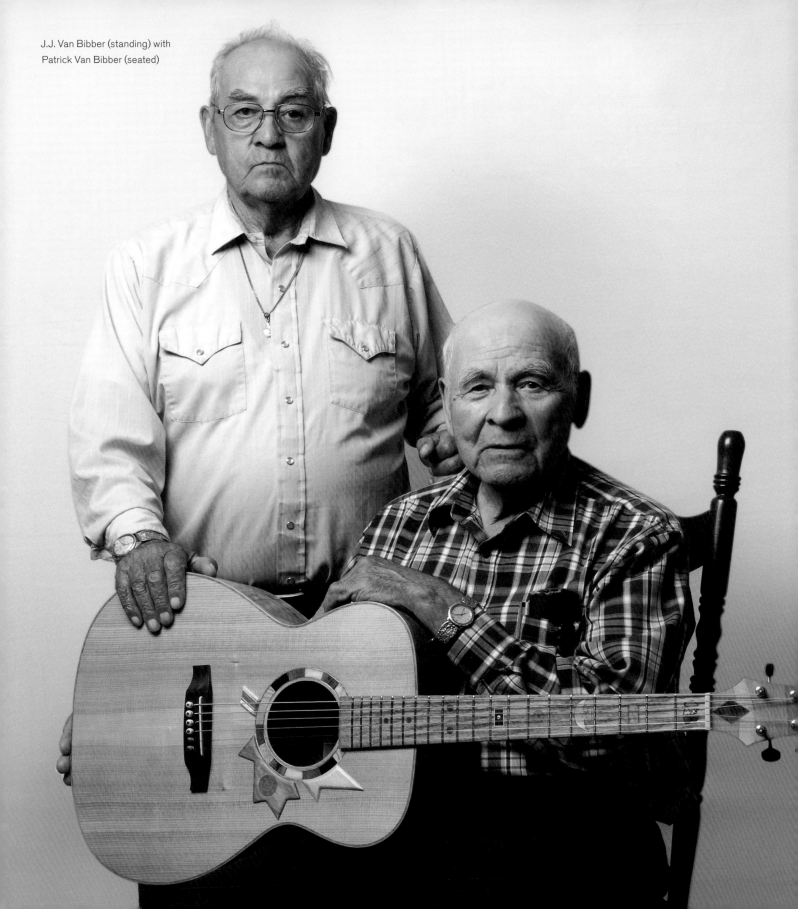

J.J. Van Bibber (standing) with
Patrick Van Bibber (seated)

YUKON

I live nowhere near the Yukon, but getting five pieces of historical material from the Territory was one of our easier tasks. After all, this part of the country was built on stories, forged in the legend of the Gold Rush with all the attendant colourful characters—not to mention the presence of luminaries such as Jack London, Robert W. Service and Pierre Berton adding to the narrative.

It was made even easier by the fact that I had visited twice and made interesting friends and contacts like Bob Unger and Marc Johnston, who wanted to help out. Plus there was my friend Bert Cervo, plus I was getting tremendous co-operation from Mike Edwards and his colleagues in the Heritage Resources Unit at the Yukon Department of Tourism and Culture. In fact, between all those folks we had secured four really interesting pieces from around the Territory, and I thought that was pretty good.

Then, just as construction of the guitar was beginning in Nova Scotia, I got an e-mail from Mike saying that the Tr'ondek Hwech'in First Nation had gone out of their way to find an early marten hide-stretcher belonging to a pioneer trapper named J.J. Van Bibber and wanted to contribute it to the project. Was there still room and still time to include it?

J.J. was born in 1920 in the middle of a pack of seven brothers. They spent much of their time together working the traplines across the Yukon. J.J. took up photography during these expeditions, becoming the pre-eminent documentarist of the trappers' life through a collection of some two thousand photographs taken between 1933 and 1945. Attached to the e-mail Mike sent was a picture the eighty-six-year-old J.J. had taken of himself standing in his kitchen in a plaid shirt playing air guitar on the hide-stretcher. How could we possibly say no?

When we visited the Dawson City Music Festival in mid-July 2006, we met J.J. and his younger brother Patrick (just 84 at the time) and did some wonderful portraits of the two of them together. During the session, we asked them about life on the traplines. J.J. talked about the animals they caught and ate, including beaver.

Doug asked, "What does beaver taste like?"

With a perfectly straight face and dead-on comic timing, J.J. looked straight at Doug and said, "Tastes like beaver."

DAWSON CITY & PELLY CROSSING, YK
Marten hide-stretcher used by brothers J.J. and Patrick Van Bibber (sons of Yukon pioneers Ira and Eliza Van Bibber) during their trapping days. J.J. went on to become a celebrated photo-documentarian of life on the traplines. COURTESY OF: J.J. and Patrick Van Bibber, with help from Mike Edwards, Yukon Tourism and Culture

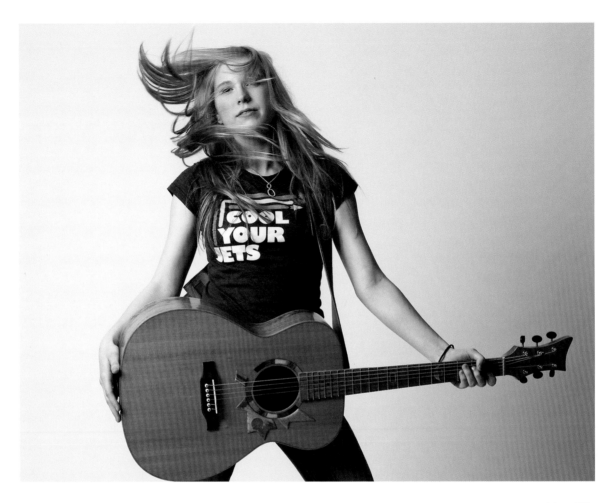

Ariana Gillis

67

IQALUIT, NVT

Whale baleen. Rather than teeth, some whales have baleen, with which they filter and eat their food. The baleen is used in Inuit craft, and in recent centuries was also common in corsets, umbrellas and other European items. COURTESY OF: Suzanne Evaloardjuk, with help from Bert Cervo

Cody Harper

CREDITS AND ACKNOWLEDGEMENTS

Portrait, event and Golden Spruce
photography by Doug Nicholson
www.dougnicholsonimages.com

Materials and construction
photography by Sandor Fizli
www.sandor.ca

Additional photography by
Sarah Gillett, Jim Panou,
Geoff Siskind and Jowi Taylor

St. Bonifice Museum photos by Robert
Barrow, courtesy of St. Boniface Museum

Six String Nation logo
design by Darren Wilson

Robert Dickson's poem "Générations"
was commissioned by Jowi Taylor to
coincide with a performance at the
Townehouse Tavern in September 2006.
It is reprinted here by kind permission
of Dickson's estate.

Lyrics to "The Longest Road"
by Stephen Fearing ©1992. They are
reprinted here by kind permission
of Mummy Dust Music Ltd./
Fearing and Loathing Music/
True North Records

HONORARY PATRONS
Bill Boyle
Charlie Coffey
Margaret Dryden
Richard Flohil
Camelia Frieberg
Al Mattes
Duncan "Dusty" Miller
David Neale
Michael Ondaatje
Bob Rae
Buffy Sainte-Marie
Donald Sutherland
Veronica Tennant

CRITICAL KICK-START
National Capital Commission
Research In Motion through the
 generosity of Mike Lazaridis
Westerkirk Capital

GUIDANCE AND PERSONAL SUPPORT
Natasha Aziz
Shawn Bailey
Allison Baillie
Erin Benjamin
Jack Blum
Elaine Bomberry
Chris Brookes

Laurie Brown
The Cameron House
Kerry Clarke
Lisa Cole
Gary Cormier
Richard Davis
Stephen Fearing
Elle Flanders
Lennie Gallant
Erella Ganon
Trevor & Christine Gillett
Judy Gladstone
Marc Glassman
Arlene Hazzan-Green
Hugh's Room
Ironwood Stage & Grill
Gerald Keddy
James Lahey
Kelly Langgard
Doug Larson
Lula Lounge
Gordon MacLeod
Peter MacLeod
Annette Mangaard
Stephen Marsh
Steve Marsh
Tom Metuzals
Mitzi's Sister

VICTORIA, BC
Wood from a doorway to Fan Tan Alley, the heart of Canada's first
Chinatown. Known as a gambler's haven, the area was frequented by male
Chinese workers who had been forbidden by Canadian law to bring their
wives or families from China. The alley was subject to frequent police raids.
COURTESY OF: Dr. David C. Lai, with help from Charlayne Thornton-Joe

Peggy Nash
Bob Nesbitt
Joanna Pachner
Paolo Pietropaolo
Hugo Rampen
Adele Sacks
Arthur Sager
Catharine Saxberg
Shingoose
The Ship Inn
Jennifer Stein
Andy Stochansky
Valerie Taylor
Lisa Whynot
Judy Wolfe
Kerry Young
Christina Zeidler
Margie Zeidler
Matt Zimbel

BUSINESS AND OPERATIONAL SUPPORT
Apple Canada Inc.
Eric Birnberg and Tom Walden
 at Behind the Scenes Services
Calton Cases
Shawna Cooper at Mom Can't Cook
Larry Davidson and all at D'Addario Canada
Holly Dennison
Andrea Dixon Design
Gary Gougher
Ron Hay
Drew Lightfoot
Heather Kelly at HKC Marketing
Lisa Kiss Design
Luis Labeque
Levy Leathers
Stephanie Marshall
Michael Meredith and Joanne Gordon at RBC
 Knowledge-Based Industries Group
Kathleen Pirrie-Adams
Annemarie Roe & Gary Myers
 at BaAM Productions

Tall Poppy Web Design
Michael Ulster
Nick Ursa

RESEARCH
Christine Atkinson
Garvia Bailey
Sid Bobb
Patrice Mousseau
Jeff Overmars
Bryan Rogers
Jason Ryle

MATERIALS CONTRIBUTORS
Katrina Anderson
Charlie Angus
David Arnason
John & Linda Aspin
Hank Avery
Joanne Beland and Parks Canada
Delvina Bernard
Patsy Berton and Rico Gerussi
Peggy-Ann Berton
Sid Bobb
Mia Boiridy, Jim Marchbank
 and Science North
Carolee Boutilier
Lynn Bullock and the Princess
 Patricia's Canadian Light Infantry
Bill Burke and Cathy Oliver
Bert Cervo
Cindy Cherry
Don Cherry
Brian Chipperfield and the
 One Arrow First Nation
Rodney Clark
Frank Collison
Brian Cooke
Armand Cote
Eva Couchie
Helen Culhane
David Curtis and Viking Air Ltd.

Charlie Cutts, Jesse Kumagai,
 Douglas Gardner and the
 Corporation of Massey Hall
 and Roy Thomson Hall
Herb Davis
Senator Consiglio Di Nino
Dinosaur Provincial Park
Bobby Doucet
Mike Edwards, Jodi Beaumont
 and Yukon Tourism and Culture
Rick Edwards
Suzanne Evaloardjuk
Linda Fibich
Don Freed and the community of Patuanak
Karl & Elizabeth Friedmann
Leo Gagnon
Lennie Gallant
Marvin Goldblatt
Russell & Katherine Gordon
John Greene
Nancy Greene-Raine
Wayne Gretzky
Guujaaw and the Council of the Haida Nation
Fred Hammer
Brian Hart
The town of Hartland, New Brunswick
Paul Henderson
Elisapie Isaac
Bebhinn Jennings
Marc Johnston
Karen Kain and the National
 Ballet of Canada Archives
Ali Kazimi
Chris Kearney
Gerald Keddy
Cynthia Kinnunen
The Labobe family
Dr. David C. Lai
Dennis Landry, Mike Large
 and Music and Film in Motion
Michael Langham
Henry Lyall

 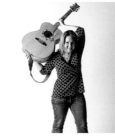 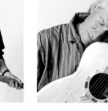

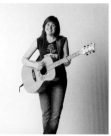 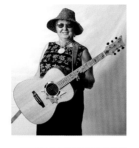 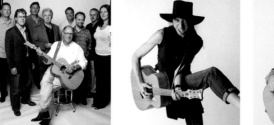 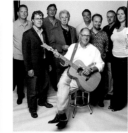 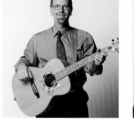 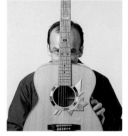

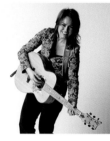 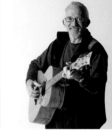 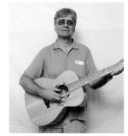 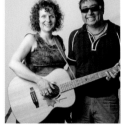

 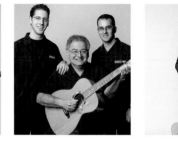 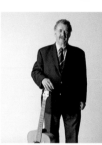

 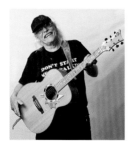

Sonny MacDonald
Gerard Machnee
John & Jenny MacNeil
Philippe Mailhot and the
 St. Boniface Museum
Kirk Makepeace and Jade West
James Mathias
Lex McKay, Senator Wilfred Moore and
 the Bluenose II Preservation Trust
Vice Admiral Duncan Miller
John A. Miller
Kelly Mollins
Blake Morton
Richard Murdoch and FCNQ
Susan Murray
Allan Muzzerall
David Myrick
Liam Myrick
Noel Myrick
Doug Olynyk and the
 Yukon Heritage Resource Unit
Philip Perepelkin and the Doukhobor
 Heritage Museum
Arno Perna and the co-op staff
 of the Hoito Restaurant
David Phillips
Jean Pilotte, Sylvie Jacques
 and Théâtre Capitole

Public Works and Government
 Services Canada
Tim Rast
Johnnie Reid
Tim Ruddy and the *Maid of the Mist*
Susan Rutledge
Don Shipley
Irwin Shlafman
Peter Skinner
Carrie-Anne Smith and Pier 21
St. John's Anglican Church, Lunenburg
Pam Steele
The Stratford Shakespeare Festival
Dr. David Suzuki
Rick Tailfeathers and
 the Kaina First Nation
Bud Thomas
Charlayne Thornton-Joe
David Treherne
Justin Trudeau
Jack Uppal
J.J. & Patrick Van Bibber and the
 Tr'ondek Hwech'in Heritage Centre
Charlene Watt
Sam Whiffen and the Department
 of Fisheries and Oceans
The Wildcat Cafe
Elois Yaxley

CONSTRUCTION
George Rizsanyi (luthier)
Sara Nasr (inlay)
Michael McConnell (shop assistance)
Nicolo Alessi (machine heads)

GUITAR CASE MODIFACTIONS
Norah Deacon, Melanie Egan,
 Bebhinn Jennings, Amanda McCavour and
 the Harbourfront Centre Craft Studio
Trudy Graham and Al Williams and
 Calton Cases North America

DOCUMENTATION
Christopher Ball
Doug Betts
Mark Blevis
Kristin Briggs
J.C. Caprara
Bert Cervo
Nick Chevrefils
Jason Delasoy
John Stuart Dick
Nasir J. Farooqi (Jabbz)
Dave Gaudet
Danny Greenspoon
Heidi Hoff
Doug Kerr
Gary Mansfield

69

PIC RIVER FIRST NATION, ON
One of several types of stone suitable for the making of ceremonial
tobacco pipes. COURTESY OF: Eva Couchie, with help from Sid Bobb

Dan Misener
Douglas Munro
Margot McMaster
Kent Nason
Darren Olson
Evelyn Pollock
Blaine Philippi and Bob
 Stamp at f8 Inc.
Bryan Rogers
Geoff Siskind

TOURING AND INSTRUMENT SUPPORT
Air Canada
Nicole Alosinac
Canadian Recording Industry Association
Capsule Music
CBC Radio
Rupert Duschene and Aeroplan
Russell Kelly, Gerri Trimble and
 the Canada Council for the Arts—
 Music Section, Touring Program
Steve Orrett
Rogers Wireless Inc.
John Sharples and Sled Dog Music
Twelfth Fret
Amanda VanDenBrock
Susan Vandendam
Stephen Voisin, Gayle Longley
 and the RBC Foundation
and all the event-specific sponsors
 across the country who helped
 to make our visits possible.

PHOTO/INTERPRETATION
 BOOTH ASSISTANTS
Christine Atkinson
Laurie Brown
Gabriel Dubé
Sarah Gillett
Kathy Hill
Heather Kelly
David Neale

Gabriel Nicholson
Sally Nicholson
Matthew Pemberton
Andy Stochansky
Susan Vandendam
Lisa Whynot
Andrew Wilcox
and all the volunteer assistants
 at festivals, schools and
 events across the country.

SIX STRING NATION GRAFFITI MURAL
Kedre Browne (Bubblez)
Jeff Cohen, the Horseshoe Tavern
 and Lee's Palace
CommunityCAVE
Chris Lorway and the Luminato Festival
Scott Mills and the Toronto
 Police Crime Stoppers Unit
Jessey Pacho (Phade)

EDUCATIONAL OUTREACH
Don Ablett
Jane Cutler
Jessica Dargo Caplan and
 the Luminato Festival
Gabriel Dubé
Don Quarles
Dan Rubin
Lorrie Ann Smith
Ingrid Whyte

FRENCH TRANSLATION
 AND INTERPRETATION
Dominique Denis
Gabriel Dubé

SPECIAL THANKS
To Scott McIntyre for the belief in this
book and Bill Richardson for the introduction;
to the directors and staff at the Banff New
Media Institute and the CanWest Global
Fellowship, which helped me spend more
time there; to Carol Toller, Peter Cheney
and Roy MacGregor—all of *The Globe and
Mail*—for the right words at the right time,
and all the other journalists across the
country who picked up on the guitar's story
at various points along its journey; to Don
Ross and the late Robert Dickson for their
inspired additions to my inspiration and
Justin Rutledge for the repeat/repeat/repeat
performances; and to Laurie Brown, Jane
Chalmers, Charlie Coffey, Lisa Cole, Sarah
Diamond, Gabriel Dubé, Sarah Gillett, Mark
Kristmanson and the amazing NCC gang,
David Neale, Doug Nicholson and Bob
Rae for the kind of faith, encouragement
and steady resolve to make this work that
resonates as much in me as it does in
the guitar.

AND FINALLY
To all of the festival directors and show
producers, event co-ordinators and club
bookers, principals and teachers across
Canada who brought the Six String Nation
project to their communities; to all the
musicians who made the guitar their own in
performances and workshops at festivals
and concerts, club dates and conferences,
sessions and school shows; and to all of
the audiences and onlookers, patrons and
passersby, students and photo subjects who
came to see and hear and hold the guitar,
anonymous donors, MySpace and Facebook
friends and Twitter followers—thank you all
from the bottom of my heart for making the
story of Voyageur, the Six String Nation guitar,
part of your own story. As an instrument, it is
deeper and wider, older and wiser, bolder and
broader because of what you left vibrating
within it when last you met. I hope you will
meet again.

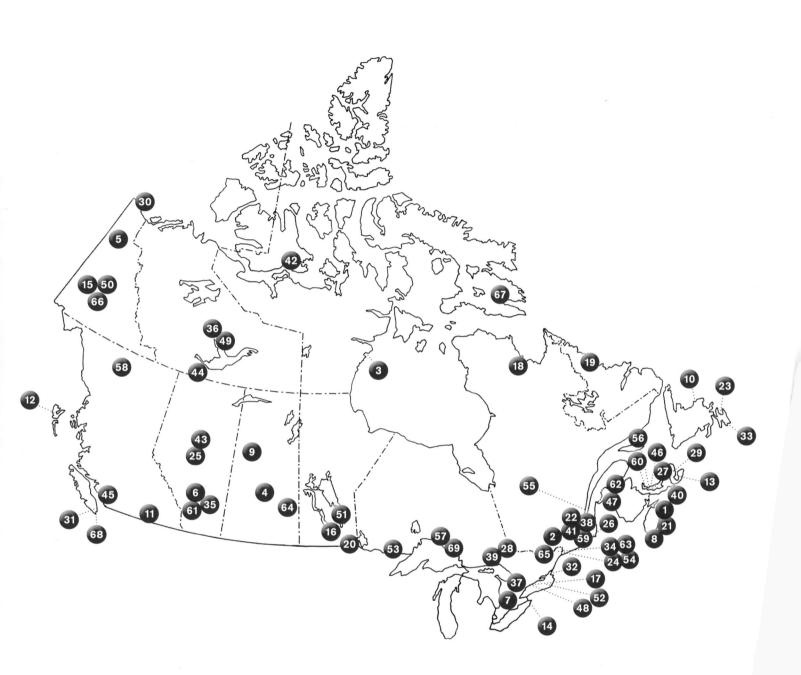

For videos, blogs, photos and more information, visit www.SixStringNation.com

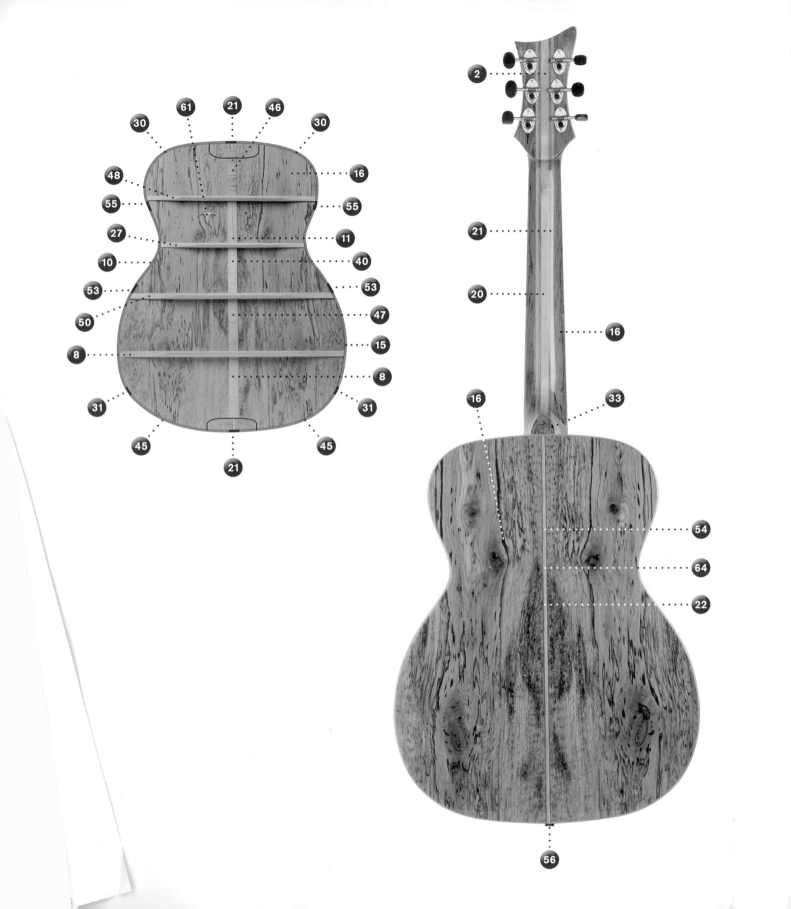